Images of Modern America

HOUSTON'S RIVER OAKS

Images of Modern America

HOUSTON'S RIVER OAKS

Charles Dain Becker and Joan Blaffer Johnson
with Ann Dunphy Becker

ARCADIA
PUBLISHING

Published by Arcadia Publishing
Charleston, South Carolina

Printed in the United States of America

Library of Congress Control Number: 2016947306

For all general information, please contact Arcadia Publishing:
Telephone 843-853-2070
Fax 843-853-0044
E-mail sales@arcadiapublishing.com
For customer service and orders:
Toll-Free 1-888-313-2665

Visit us on the Internet at www.arcadiapublishing.com

To my mother, father, and sister.
—Charles Dain Becker

To my mother, father, and children.
—Joan Blaffer Johnson

To my family and friends who love history as I do.
—Ann Dunphy Becker

CONTENTS

ACKNOWLEDGMENTS

The authors would like to thank Francita Stuart Ulmer, Sarah Rothermel Duncan, Dorothy Knox Howe Houghton, Joanne King Herring, SallyKate Marshall Weems, Mary Bain Haralson Pearson, Bain Pearson Pitts, Kandy Kaye Horn, Rhetta Moody McAlister, Gervais Bell, Robert Dabney, Randy McKinney III, Lil Nelms, Kirby Black, Bess and Milton Black, Nancy Guest, Rhonda Barclay, Gina Vosko, Rufus Cormier, Sue Trammel Whitfield, Ann Haugen, Michael Flores, Jim Olive, Susan Muncey, Sarah Jackson, and Miki Norton.

INTRODUCTION

With no context, the name *River Oaks* conjures images of tall trees next to a coursing river in the heart of a dense forest. To many in Houston, this is not the case. There are trees in River Oaks, but the longest shadows there are cast by the great men and women who have called River Oaks their home. There are bayous in River Oaks, but the strongest current one would feel there is the current of power and influence running through it. River Oaks is indeed surrounded, although not by dense forest, but by the thriving metropolis of Houston, Texas.

River Oaks is a neighborhood. To be exact, it is 1,100 acres of neighborhood, spanning east-west from Shepherd Drive to Buffalo Bayou and north-south from Willowick Drive to Westheimer Road. Known for wide, expansive boulevards and big, lavish houses, River Oaks is some of the most valuable real estate in the Houston area. The most valuable River Oaks plot, however, is the place that it holds in the hearts and minds of Houstonians.

There are many nice neighborhoods in the Houston area, many of which have houses and acreages that rival those in River Oaks, but none have quite the storied history and elaborate reputation. Originally built as a suburb of a rapidly expanding Houston, River Oaks is now—at least in terms of the Houston metropolitan area—centrally located. There is no other neighborhood in the Houston area that has the aspirational quality that River Oaks does. Some are born into River Oaks, but to many, to live in River Oaks is to have made it. It has been home to astronauts, oil barons, doctors, teachers, and everything in between. What makes a neighborhood a community are the people. What makes River Oaks such an extraordinary community are the extraordinary people who have lived there.

Many of Houston's greatest philanthropic and artistic endeavors trace their roots to River Oaks. Parks enjoyed by Houstonians throughout the year are built and cared for through funds raised by River Oaks residents. Every Christmas, people from all over the city pour into River Oaks to drive up and down the boulevards, admiring the Christmas decorations. The Museum of Fine Arts Houston, the Glassell School of Art, the Houston Symphony, the Houston Grand Opera, and the Houston Ballet have all been touched by the patronage of residents of River Oaks at one time or another. Furthermore, River Oaks residents are counted among the nation's most prolific political donors.

The stature of the residents and the community's high profile may make it seem like River Oaks is all about philanthropy, politics, and the arts. In this book, River Oaks is examined not as a political, cultural, and commercial powerhouse, but as a place where people come together to have fun, be with family, and practice their faith. In short, this book shows what makes River Oaks the neighborhood River Oaks the community. The book follows several families through several decades to give an intimate portrait of their lives and homes to give the most authentic sense of time and place possible.

One

1960–1989

On any given day or night in Houston, one might see the residents of River Oaks out and about, acting as the city's biggest tastemakers, tycoons, philanthropists, and socialites. When they return home, however, they want what any Houstonian might want: family, friends, privacy, luxury, and safety. For the past 93 years, River Oaks residents have enjoyed all that and more in their little corner of the world between Lamar High School and River Oaks Country Club.

What has brought families to River Oaks over the years may have been different, but they all seem to enjoy the same things about it. When the families represented in this book and other longtime residents of River Oaks were interviewed and asked what the most iconic sites in the neighborhood have been to them, the same answers came up with almost every person asked: the River Oaks Theater, St. John's Church, River Oaks Garden Club and Forum of Civics, River Oaks Country Club, River Oaks Gate Pier Light, and Pumpkin Park.

Similarly, the families may have been different, but when asked for their family photographs and memories, it was clear they cherish the same things about life in River Oaks that any other Houstonian would. Bess and Milton Black grew up blocks apart and would not meet for almost 20 years. Mary Bain and Gary Pickney Pearson Jr. wanted their children to have the kind of ideal childhood a family-oriented neighborhood like River Oaks can provide. Lil Nelms was one of the River Oaks Carter family members who moved away and resettled there later in life because it always felt like home. Some families, like the Blaffers, built such a splendid community for themselves in River Oaks that it was only natural they would build an even bigger, happier family there through the Blaffer-Trammell nuptials in the late 1970s and then through the Blaffer-Johnson nuptials in the 1980s.

The places may evolve, and some names may change, but to its residents, River Oaks excels at being what anyone wants out of their neighborhood: a place to raise a happy family and build a hefty fortune.

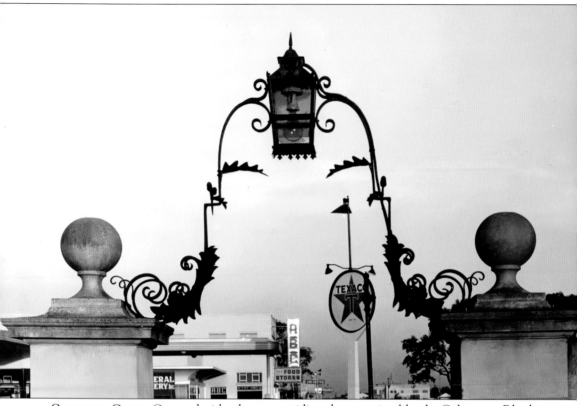

CROWNING GLORY. Crowned with a lantern, striding the gate piers like the Colossus at Rhodes, this dancing filigree ironwork has become a symbol of the tasteful yet conspicuous elegance that has come to define River Oaks. The Gate Pier Light is the crown jewel of River Oaks, greeting all who enter. Architect John Staub and developer Hugh Potter hired E. Wayne Sturdivant to build the Gate Pier Light. Like many in River Oaks, Sturdivant came by wealth and renown with just a dream and a skill. (Courtesy of Joan Hazelhurst.)

E. WAYNE STURDIVANT. At a young age, E. Wayne Sturdivant moved to Houston, where he founded the Southern Electric Company and served as its first president. He led this company to make some of Houston and the Southwest's most famous light fixtures. He eventually married Celeste Eleanor Rhodes, the daughter of the assistant postmaster, Omer Rhodes. (Courtesy of Pat and Bill Bremer.)

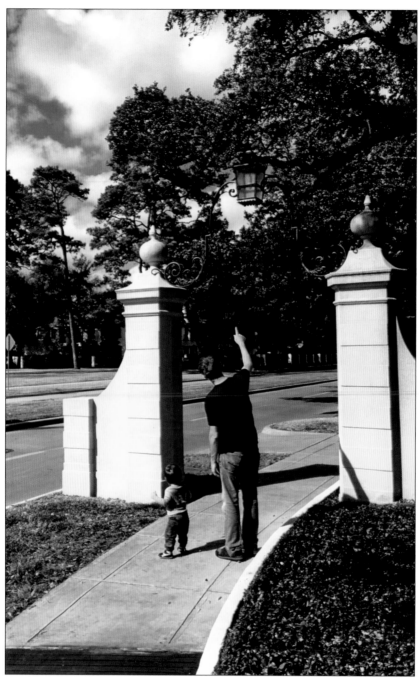

GATES OF PARADISE. If the Gate Pier Light is the crown jewel of River Oaks, then the gates themselves are the king's robes—sending a message of regality, sturdiness, and subtle opulence. Don Q. Riddle, the brilliant marketer for the River Oaks Corporation, knew early on the benefit of branding River Oaks to prospective clients and the role the gates designed by John Staub would play in that branding. Still today, that branding lives in the minds and hearts of those living in River Oaks who grace the pages of this book. Sturdivant's grandson Bill Bremer and great-grandson Connor Jackson examine the timeless craftsmanship of their ancestor. (Courtesy of Pat Schwab.)

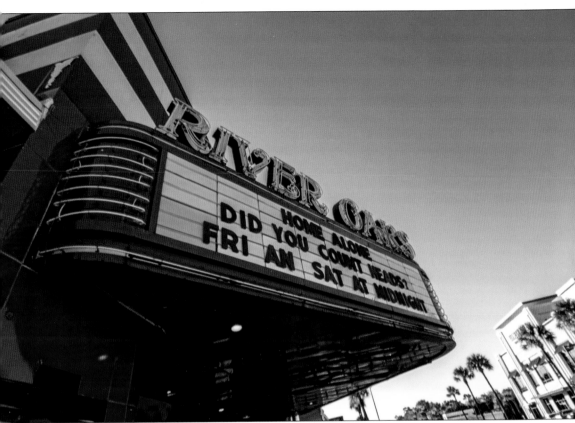

RIVER OAKS THEATER. The River Oaks Theater was one of the last Art Deco buildings constructed in Houston. River Oaks residents are devoted to this iconic theater, protecting it from being sold or demolished since 1939. It still has its original marquee. (Courtesy of David Purdie.)

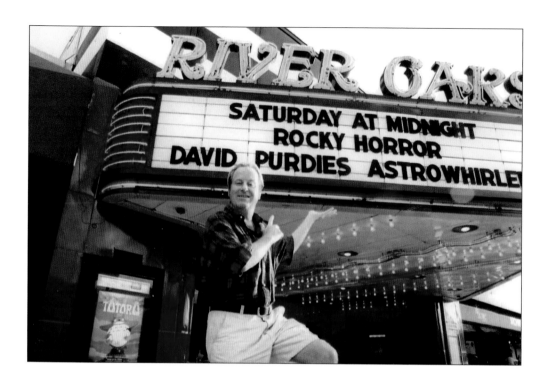

AND HIS NAME IN LIGHTS. River Oaks local David Purdie (pictured above) fondly remembers his childhood on Del Monte Drive: "We had the best Kool-Aid stands giving away *Richie Rich* comic books if the customer purchased three cups!" He frequented the River Oaks Theater but never imagined that one day he would produce an independent film titled *AstroWhirled*, which won a competition at the Aurora Picture Show, a nonprofit media arts center in Houston that presents artist-made, non-commercial film and video. The advertisement below ran in a 1939 publication announcing the new theater. (Both, courtesy of David Morris Purdie.)

See you at the opening of our own

NEW *River Oaks* THEATRE

Watch for the date!
(SOMETIME THIS MONTH)

SEE OUTSTANDING MOVIES IN PERFECT COMFORT

TEXACO. William T. Campbell, whose descendants still live in River Oaks, signed the original charter of the Texas Company, a little oil and gas business that became Texaco. His daughter married Robert Lee Blaffer (pictured), one of the founders of Humble Oil. Texas governor James Hogg, a partner of Campbell's, later called the marriage, "the conglomerate of the century." The Texaco pictured below, which was long a fixture along Shepherd Drive, was purchased in the 1960s by Sal Gambino, a career police officer who patrolled the River Oaks area and bought the station as soon as it became available. (Right, courtesy of the San Jacinto Museum; below, courtesy of Patty and Sal Gambino.)

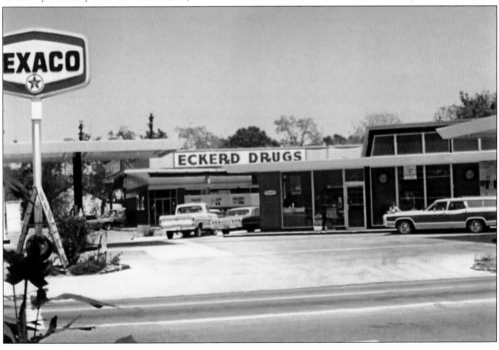

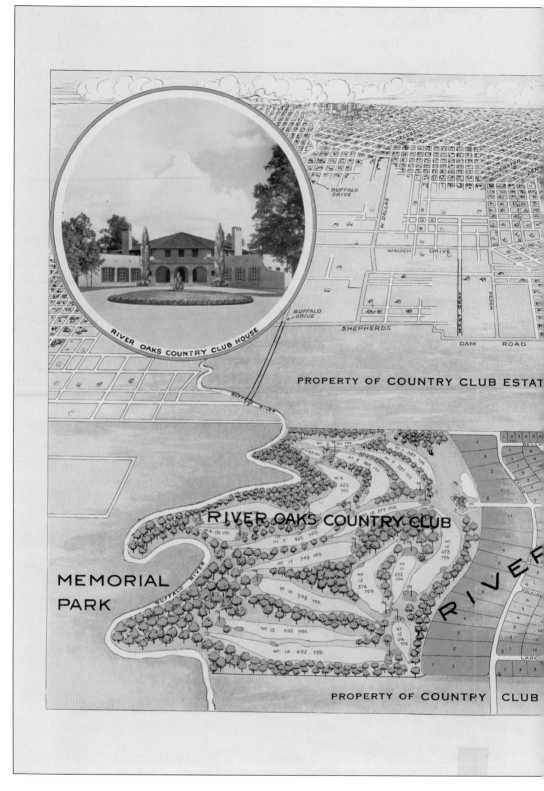

RIVER OAKS COUNTRY CLUB HOUSE

BUFFALO
DRIVE

W. DALLAS

WAUGH DRIVE

PEDEN

WEST GRAY

BUFFALO
DRIVE

SHEPHERDS

DAM ROAD

PROPERTY OF COUNTRY CLUB ESTAT

MEMORIAL
PARK

RIVER OAKS COUNTRY CLUB

No 2 311 yds.

No 8 365 yds.

No 9 385 yds.

No 4
425
YDS.

No 10 579 YDS.

No 6 132 yds.

No 7 445 yds.

No 17 348 YDS.

No
10
473
YDS.

No
11
232
YDS.

No
12
374
YDS.

No 16 398 YDS.

RIVE

No 13 402 YDS.

No
15
174
YDS.

No 14 492 YDS.

PROPERTY OF COUNTRY CLUB

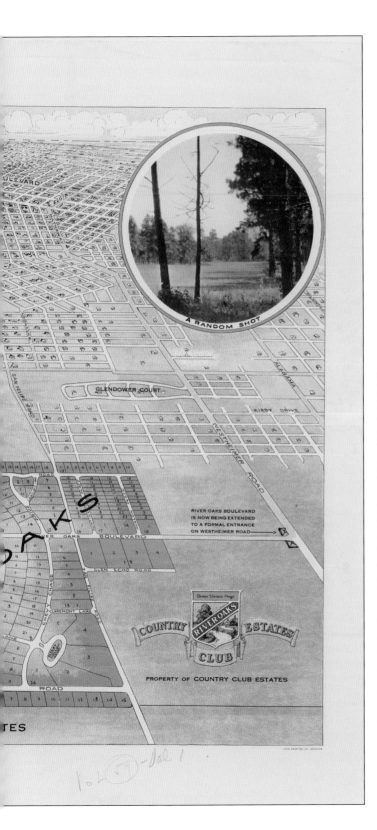

ORIGINAL RIVER OAKS
PLAT. The area where
River Oaks was first platted
was originally considered
farmland, not residential.
The subdivision was
planned to be affordable
to every income level. In
1925, property was selling
for as low as 25¢ per square
foot. Hugh Potter wrote in
a letter to his sales force,
"You can without question,
feel that you are selling this
property at such a price
as to make it an excellent
investment for anybody."
The streets in Country
Club Estates were named
for famous golf courses, like
Chevy Chase, which is in
Maryland, in a suburb of
Washington, DC; Inwood
on Long Island, outside of
New York City; Del Monte
in Monterrey, California;
and Sleepy Hollow in
Scarborough-on-the Hudson,
New York. (Courtesy of the
Harris County Archives.)

17

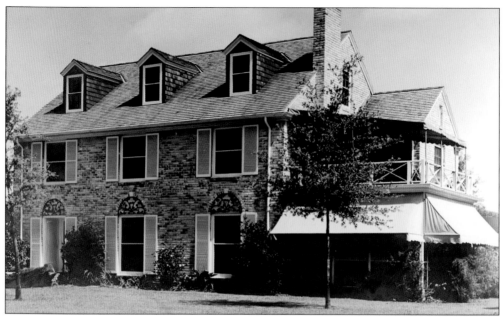

ROCK. The home seen above was built by the River Oaks Corporation in the 1930s. Bess Kirby Tooke was born in this house the year her parents bought it. Tooke remembers, "My home was a place where my friends would come for dinner, play on my swing set and have slumber parties." She reminisces about her home, continuing that it "had a finished third floor with a large attic fan and no air conditioning. Most fences were cyclone, so we knew neighbors all around us. My parents would stand on the steps and whistle for me to come home for dinner. In those days, our milk and vegetables were both delivered to door. It was a simpler time." The house below was built over the original by a new owner in 2001 and has 16 rooms. (Courtesy of Bess and Milton Black.)

NEIGHBORS. Bess and Milton England Black are a River Oaks love story. Growing up literally blocks away from each other, their wedding reception was at the River Oaks Country Club. Milton Black's home, seen below, was built in 1938 by the River Oaks Corporation on Ella Lee Lane. Milton remembered, "I loved to walk the wall on the house behind us, and I slept with my head in the window, trying to stay cool. My family raised chickens behind the house, and George Brown's farm was just at the end of the next block. I would ride my horse home from the Bayou Club and leave him overnight in the backyard. I'd pick blackberries, play 'kick the can' with my friend Dale Cheesman, and walk to both the River Oaks drugstore and school." (Both, courtesy of Bess and Milton Black.)

CLOSE FRIENDS. River Oaks was a close knit neighborhood. Bess Tooke's family were friends with the Burkes. Dr. Thomas Burke, George Anna Lucas Burke, Ria Lucas Gable, and Jack Belvedere were present at the Bess and Milton Black wedding reception at the River Oaks Country Club. (Courtesy of Bess and Milton Black.)

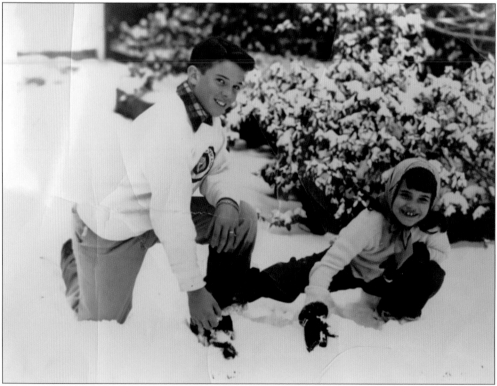

RARE SNOWFALL IN HOUSTON. Thomas and George Anna Burke lived on Wickersham in a home designed in 1938 by two of Dr. Burke's patients: architects Tolbert Wilson and Sy Morris. On a rare snowy day in Houston, siblings Thomas Walker Burke Jr. and Maria (Burke) Butler enjoy a photo opportunity on their front lawn. (Courtesy of Maria Burke Butler.)

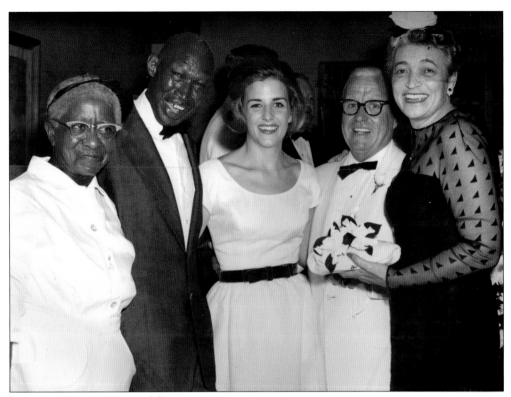

LIFETIME FRIENDS. Pictured from left to right are Willie and Jim Wiley; Bess and her father, C.E. Jack Tooke; and Marjorie Lee Kerr. Jim was a loyal employee of John Henry Kirby from when they met until Kirby's death. The Kirbys, in turn, were very fond of the Wileys, who would babysit Bess at times and worked full time at John Henry's Kamp Kil Kare, located on Armando's Bayou. After John Henry passed, Jim went to work for George Brown on his land—now Royden Oaks. Marjorie Lee Kerr was the daughter of T.P. Lee, builder of the Link Lee Mansion on Montrose Boulevard, which is now home to the University of St. Thomas. At right, a young Bess Kirby shows her dad the riding skills Jim taught her at Kamp Kil Kare. (Both, courtesy of Bess and Milton Black.)

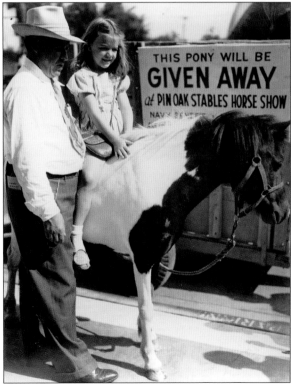

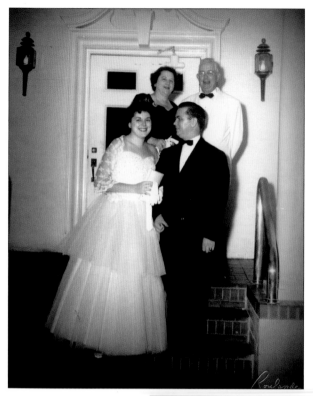

THE PEARSON FAMILY. In the photograph at left, debutante Mary Bain Haralson's father is watching her and Gary Pickney Pearson Jr. saying goodbye before her debut, and it looks like he had something to say. Several years after this River Oaks rite of passage, Mary Bain and Gary Pearson bought their home on Olympia Drive, where their three children, pictured below from left to right, Jim, Bain, and Gary grew up in a neighborhood full of children. Not one to be idle, Mary Bain Haralson Pearson taught school; served on the board of directors of Holly Hall, a Christian Retirement Community; and was a congressional witness to the Enron debacle. (Both, courtesy of Mary Bain Pearson.)

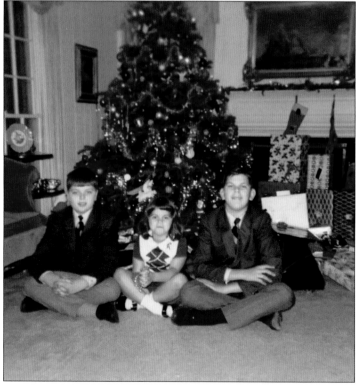

SOUTHERN LIVING. Pictured at right driving his carriage is Stewart Morris Sr., living two of his passions: history and horses. He participated in the 200th anniversary reenactment of George Washington's funeral and financed the restoration of the stables and carriage house at Mt. Vernon. Morris is escorting Jim and Nancy Guest and Jessie Lee Schindler, all dressed in period clothing, to a debutante ball at River Oaks Country Club (where it is held every January). Pictured below is the house where the Guest family lived for 35 years. Today, the land is a vacant lot owned by the Protestant Episcopal Church Council of the Diocese of Texas. (Right, courtesy of Nancy Guest; below, courtesy of Joan Johnson.)

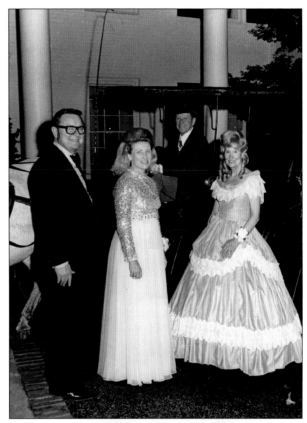

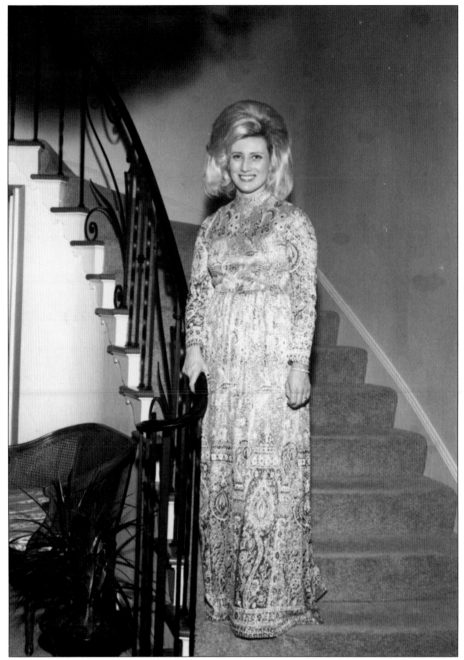

FASHION-PLATE. Nancy Guest pauses for a photograph before welcoming her guests as hostess to one of her famous parties. The Guests' 1930s River Oaks Boulevard home was a venue lent to all of the organizations to which they belonged, including the Houston Junior Woman's Club, the Assistance League, the Blue Bird Club, the Daughters of the Republic of Texas, the Daughters of the American Revolution, the United Daughters of the Confederacy, the Colonial Dames of the 17th Century, and the Daughters of the War of 1812. A true daughter of Texas, Nancy personifies the time, descending her carpeted and wrought-iron stairs, dressed to the nines with a perfect bouffant. (Courtesy of Nancy Guest.)

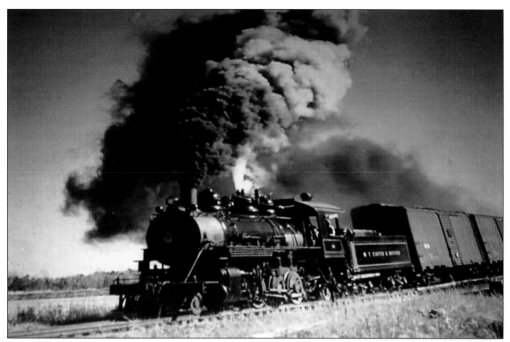

INDUSTRIOUS CARTERS. With many family members currently living in River Oaks, the Carters' presence is as large as their legacy is long. This train was one of 12 owned by the W.T. Carter and Brother Company, which traveled over a million miles of tracks with timber from the Carters' lumber processing mills. As their lumber was essential in the next generation of Houston homes, so were their children fixtures in the next generation of Houston society. The Carters had seven children, of whom daughter Agnese Carter Nelms is shown at right in a Robert Joy portrait. She was self-educated and highly active in the community. She established Planned Parenthood in Houston and was devoted to education on birth control. She lived on Sleepy Hollow Court in River Oaks. (Courtesy of Lil Nelms.)

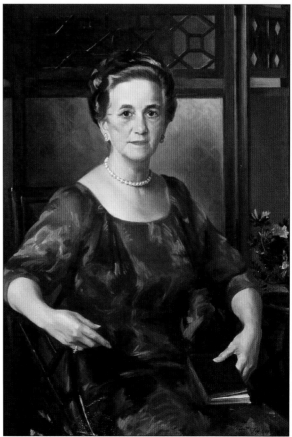

Fox Hunting to Debutante. Cousin Thomas L. Carter escorts Lil Nelms during her Allegro Presentation. Agnese Carter Nelms persuaded her granddaughter to come to Houston and be introduced to society. The dress she wore was designed in New York, and a debut party was held in the Shamrock Hilton's gigantic ballroom. (Courtesy of Lil Nelms.)

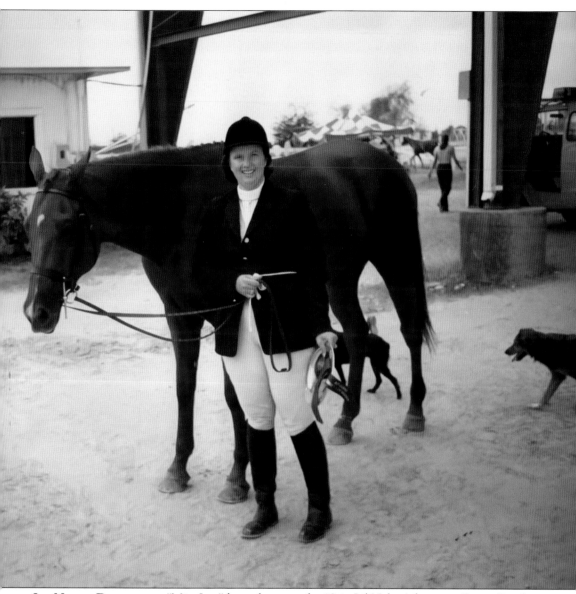

LIL NELMS, DEBUTANTE. "Miss Ima" hosted a party for 10 in Lil Nelms's honor at Bayou Bend. Nelms remembered, "I was like a deer in the headlights. You can imagine that I had never been to events quite like these given in my honor. My normal day was three hours of morning classes at Gunston School and then working with my horses until dinner." She is pictured with one of her horses at the Pin Oak Charity Horse Show, which benefits Texas Children's Hospital. (Courtesy of Lil Nelms.)

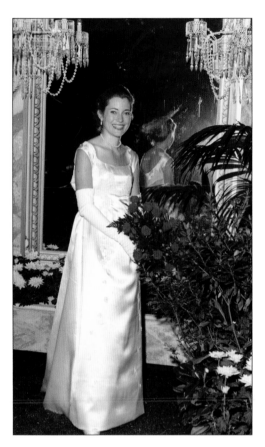

AN EVENING OUT. Dallas's social season officially opens in November, the night of Idlewild, and officially concludes with the final bow of the debutantes at the Terpsichorean Ball in mid-January. Founded in 1884, it is still a highly sought-after invitation, and although in Dallas, Idlewild fixtures heavily in the River Oaks social climate. Pictured at left at Idlewild is Joan Johnson. Her dress was made by a Houston dressmaker who used a French-designed dress belonging to Joan's sister Sarah Blaffer Hardy as the pattern. Joan's grandmother Kate Davis supplied the material. Below, from left to right, Joan's mother Camilla Davis Blaffer attends a charity event with world-renowned surgeon Dr. Michael DeBakey and Pat McMahon. Camilla was a graduate of Wellesley College and the mother of five children. (Both, courtesy of Joan Johnson.)

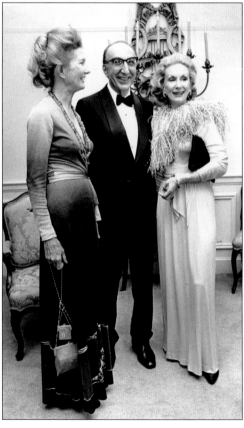

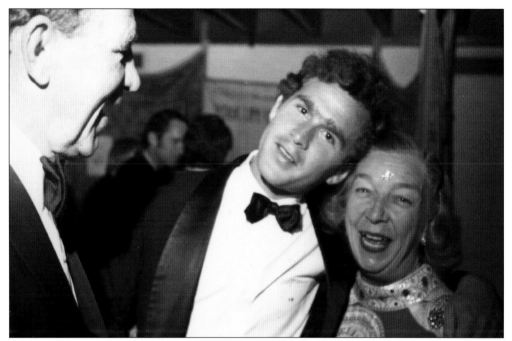

FAMOUS FACES. Above, at Christmas 1973, Harry Hurt II (left) and future president of the United States George W. Bush engage Fay Griffith at the Hurts' beautiful home on Troon Road. Hurt's son and namesake, Harry Hurt III, became an award-winning journalist and the author of six non-fiction books. George Bush attended the Kinkaid School, Yale, and the Harvard Business School, and was the 43rd president of the United States. Pictured below from left to right are Harry Hurt II, his wife, Margaret "Magee" Hurt, and River Oaks resident Preston White. (Both, courtesy of Joan Johnson.)

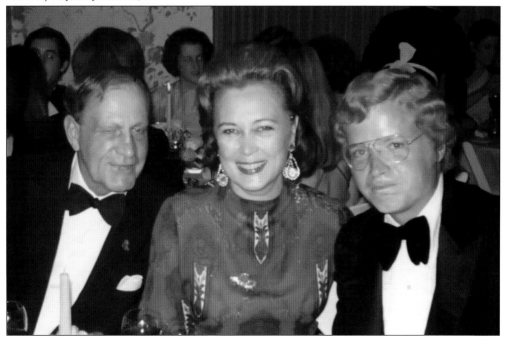

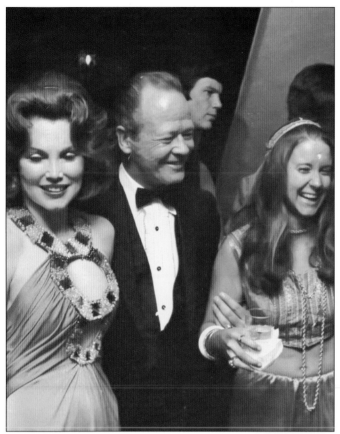

AN INTERNATIONAL PROFILE.
At left, Joanne King Herring,
her husband, Bob Herring,
and Fay Crow Morris attended
Joan Blaffer's debutante
party at the Bayou Club.
Herring's grandfather was
William Sampson, a resident
of River Oaks who owned
the Texas Sand and Gravel
Construction Company and
was a founder of Houston
Baptist University. Joanne
remembers, "My grandfather's
house had a 50-foot staircase
going down to Buffalo Bayou.
Even so, during the flood
of 1935, the water in the
library was up to an adult's
knees." Joanne was awarded
a Congressional Gold Medal
in 2015. The movie *Charlie
Wilson's War* was brought
to the big screen, and Julia
Roberts played in Joanne's
real life story. Pictured below
is Joanne and Bob Herring's
home on Inwood Drive. (Both,
courtesy of Joan Johnson.)

OUT AND ABOUT. During the debutante season, each set of parents gives at least one party for their daughter. Joan Blaffer Johnson's parents threw her an affair in 1973 at the Bayou Club where all in attendance—including many of Houston's most prolific philanthropists—wore festive costumes. Pictured are attendants Lynn Sakowitz Wyatt (left) and Claire Atwood Glassell, who chose to wear kimonos. Below, the Wyatt home on River Oaks Boulevard next to the River Oaks Country Club has changed hands only three times. Built by John F. Staub for Hugh Roy Cullen in 1933, the home was purchased by Lynn and Oscar Wyatt and recently purchased again by the Flores family in 1999. (Both, courtesy of Joan Johnson.)

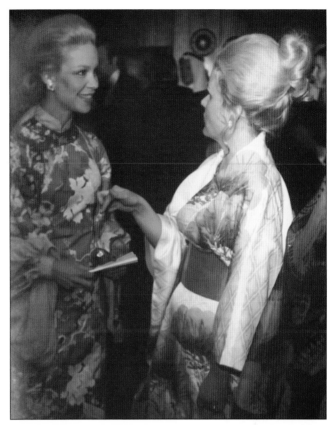

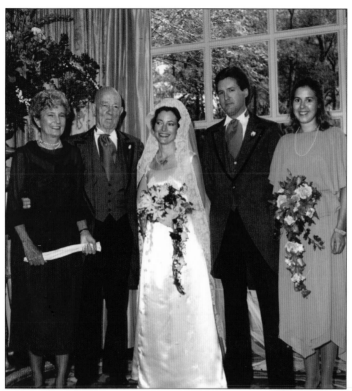

RIVER OAKS WEDDING, 1979. Pictured above from left to right are Camilla and Tex Trammell, newlyweds Joan and Luke Johnson, and bridesmaid Martha Farish Otie. The Johnsons were married at St. John the Divine's Chapel, blending two iconic Texas oil families. Joan and Luke were both raised in River Oaks, attending St. Johns School on Westheimer Road. Joan's widower stepfather, Tex Trammell, gave the bride away. The Johnson wedding reception was held in the home of Tex and Camilla Trammell at 2 Briarwood Court. At right, Tex and his first wife, Susie Ella "Sweetie" Fondren, lived in River Oaks on Willowick Drive, where they raised three children together. They met while Sweetie was a student at Rice University. The third generation of Fondren, Trammell, and Underwood children still reside in River Oaks. (Both, courtesy of Joan Johnson.)

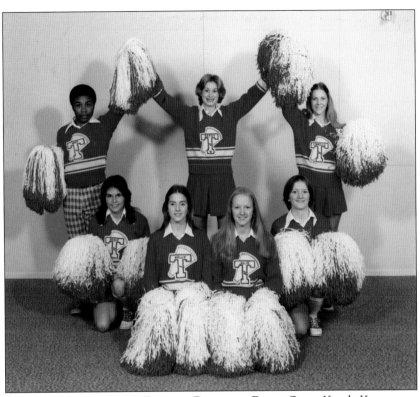

RAGS TO RICHES TO RIVER OAKS. Kandy Kaye Horn, pictured above as head cheerleader at Terrell High School, is one of the many stories of those who made it into River Oaks with a dream and a whole lot of grit. From living in government housing in Terrell to receiving an MBA from the University of Texas, to finally landing in the house once owned by governor of Texas John Connally, her story is one of a lifetime of big smiles and nose-to-the-grindstone work. She is chair of Horn Family Foundation, which funds Houston Food Bank, Living Water Inc., and Texas A&M scholarships and veterinary school. (Both, courtesy of Kaye Horn.)

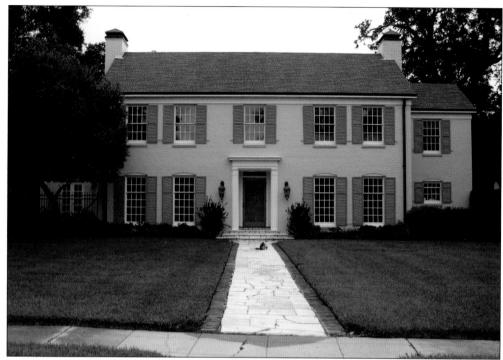

TROON ROAD. In 1935, architect Cameron Fairchild designed this traditional Georgian home, which was built by E.B. Crawford. In the mid-1980s, the house was purchased by Dr. Ralph E. Norton and his wife, Michaelene "Miki" Lusk Norton, who lived there for 30 years. A River Oaks native, as a newborn, Miki Lusk moved into her grandparents Tanny Charles and Lena DeGeorge Guseman's home at 1908 River Oaks Boulevard (below). Guseman built this home in the 1930s for his wife and three daughters, Lenora, Ursula, and Michelene, and his sister-in-law Rosalie DeGeorge. Architect Robert K. Maddrey designed the Italian-French style home with Italian gardens. (Both, courtesy of Michaelene "Miki" Lusk Norton.)

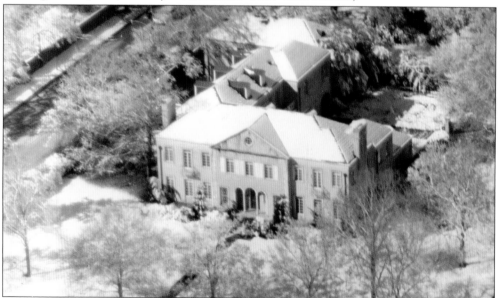

TROON ROAD INTERIOR. The Troon House addition had a garden room ideal for entertaining. It was surrounded with six full-length glass doors that opened onto steps as wide as the house, cascading down to a large tabby shell terrace and swimming pool. The elegant, square original dining room was on the front of the house overlooking a side garden. The round marble dining table, which seats 10 guests, was designed by David Stone Interior Design and custom made by Jaime Rios Inc. The crystal chandelier was from the home of the owner's grandparents at 1908 River Oaks Boulevard, Tanny Charles and Lena DeGeorge Guseman. (Both, courtesy of Michaelene "Miki" Lusk Norton.)

HOME GROWN SWIM LESSONS. Michael Norton could ask the entire class over for a swim party in this luxurious backyard pool at his Troon Road house. Below, in 1988, (from left to right) friends McComb Dunwoody, Robert Plumb, and Michael Norton stopped playing long enough for Michael's mother, Miki, to snap this photograph. The Nortons' large terrace pool and backyard were the scene of years of private swim lessons for neighborhood friends, end-of-school-year swim parties for Michael's class at River Oaks Baptist School, Post Oak Little League baseball teams' end-of-season celebrations, and Michael's July birthday parties. (Both, courtesy of Michaelene "Miki" Lusk Norton.)

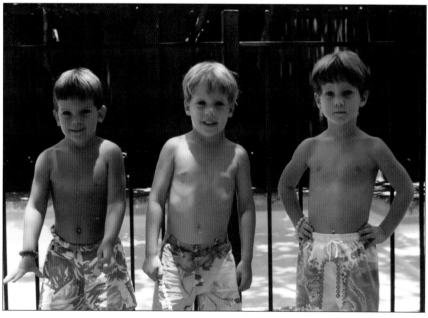

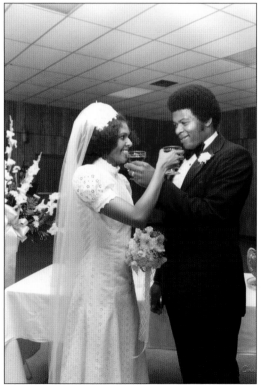

THE COUNTRY GALS. Pictured above from left to right, Jae Boggess, Mollie Bracewell, Laura Donnelly, Jane Mosbacher, and Claire Cormier Thielke took their job as a country girl singing group seriously, holding daily practice sessions during recess at St. John's School. They performed at all manner of parties leading up to and during the Houston Rodeo season. This photograph of the Country Gals was taken in the front yard of the Cormier home. At left, Claire's mother Yvonne Cormier graduated from Baylor Medical School in 1986. Yvonne served a rotation in cardiac anesthesia with Dr. Michael DeBakey and was delighted to receive her diploma from the world-renowned cardiologist himself at the ceremony. She and her husband, Rufus Cormier, are pictured here as newlyweds. (Both, courtesy of Rufus Cormier.)

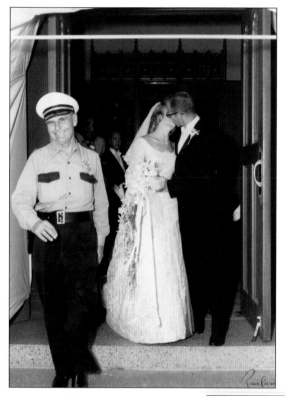

THE VENERABLE TOM SAWYER. Bess and Milton Black enjoy their first (or second, if you count the one at the altar) kiss as a married couple. Happily strolling toward the camera is Capt. Tom Sawyer. Just as his namesake was a fixture in the memory of America for centuries, Tom Sawyer was a fixture in the memory of River Oaks for decades, the omnipresent jovial security hired for weddings, balls, and galas. He eventually became a cherished part of the families for whose treasured events he was providing security. Below, the grand dame of Houston, Ella Cochrum Fondren, enjoys a moment with Tom Sawyer at an event at the River Oaks Country Club in the early 1970s. (Both, courtesy of Bess and Milton Black.)

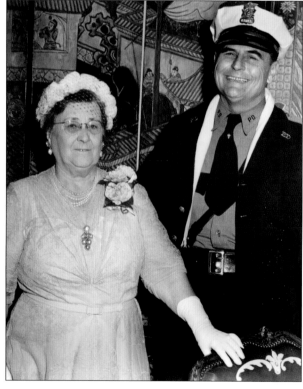

Two

1990–2000

By the 1990s, several generations of River Oaks tastemakers, tycoons, philanthropists, and socialites had come and gone. Fortunes were made and lost. Just as elsewhere, people stayed focused on fun and family.

There are several parks in River Oaks, including one of the world's finest country clubs, but many residents find other ways to have fun. When it came to enjoying life, perhaps none were as prolific as Ricky di Portanova, a Cullen prodigal son who came to Houston from Italy to make it his home. For his wife Sandra's birthday, he cut a $12 million deal in which he gave her part of the swank 21 Club in Manhattan. Others had fun simply being in River Oaks, as those at the Guest home could tell you. There, Matt Dillon could be spotted sitting on the front swing between takes of *Liar's Moon*, talking to resident Rhonda Guest Barclay. Stewart Morris, whose cousin Carlos kept a stable on his Inverness Drive estate, had his fun through his lifelong love of horses. For all of his time in River Oaks, his carriages were one highlight of the debutante season as they escorted debutantes from the pre-ball party to the River Oaks Country Club debut, midnight brunch, and dance.

River Oaks is not merely about the finer things, as many who raised big families there can tell you. Michaelene "Miki" Lusk Norton arrived at her grandfather Guseman's home as 1908 River Oaks Boulevard as an infant and decades later raised her own family on Troon Road. Her son Michael, his cousins, and friends attended parties hosted on Inwood Drive at a home they called the "Avery Castle," which benefited the Houston Public Library and made all of Houston a better place for families. Nancy Guest lived on River Oaks Boulevard, and Beth Liebling lived on Kirby Drive across from Rienzi, a part of the Houston Museum of Fine Arts, where both women raised five children. Anyone could see why many residents choose to raise families in River Oaks. Aside from the fantastic parks and beautiful houses, the area is served by several churches and schools; among them are Lamar High School, River Oaks Baptist, and St. John's School, one of the finest college preparatory institutions in the nation.

NOBILITY ON RIVER OAKS BOULEVARD.
Pictured at left, Baron Enrico "Ricky" di
Portanova was one of the most famous of
a group of wealthy partiers known as the
jet set. Grandson of Hugh Roy Cullen,
di Portanova was not just a social fixture
in Houston, but was also frequently seen
in New York, Acapulco, and many other
illustrious locales. Like his grandfather, di
Portanova lived on River Oaks Boulevard.
He and his wife, Sandra, had homes in
Houston, Rome, and Acapulco. Before
claiming his fortune, Ricky was a jewelry
designer in Italy, and his wife, Sandra, is
pictured here wearing his design of rare
gold coins set in diamond pentagrams.
Many fixtures of the River Oaks social
scene are familiar with the view below:
the di Portanovas' home at sunset. This
house was the site of many fabulous
theme parties and fundraisers once the
di Portanovas decided to settle down
and roost here toward the end of their
lives. (Both, courtesy of Joan Johnson.)

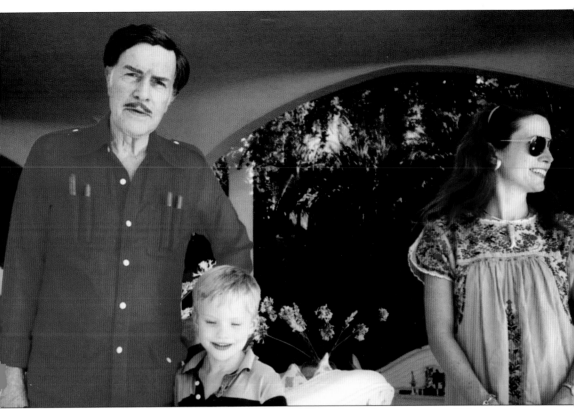

Como Le Hacen En Arabesque. When not at home, the di Portanovas could be found at Arabesque, their lavish aquatic estate in Acapulco. A Moroccan-style villa perched above Acapulco Bay, Arabesque had its own underwater-themed disco called Poseidon Discotheque, and a guest could show up to a party there in swimwear and never change, since one could actually swim from room to room due to the extensive indoor pool. They entertained guests such as Joan and son Seth Johnson, pictured here, frequently. Neighbors included Warren Avis of Avis Rent-A-Car, whose estate was called La Cabranca, and the Esandon family, whose home was called La Serena, or Mermaid. The outfit Ricky is wearing here is his evening smoking attire, complete with cigars in his breast pockets. (Courtesy of Joan Johnson.)

APPRECIATION OF FINE ART.
Sarah Campbell Blaffer passed an appreciation of the intricate beauty of rare paintings to her granddaughter Jane Owen (left). Behind her is the original Mogliani painting that hung in her home. Friends like fellow River Oaks resident Rosalie Hitchcock (right) were delighted by the exquisite art accompanying the exquisite entertaining. The Blaffer family's love of art did not stop in the home, as is clear to anyone who has ever been an unwitting beneficiary of theirs by touring the Museum of Fine Arts Houston. Jane's father was Kenneth Owen, a petroleum geologist who made his career at Humble Oil and Refining Co. Her parents had a long time to appreciate art, as her mother lived to 95 and her father to 98. Jane Dale lived in the home pictured below on Del Monte Drive. (Both, courtesy of Joan Johnson.)

FAMILY TIES. Above, from left to right, Kathy and Charles M Lusk III, Michaelene "Miki" Lusk, and Dr. Ralph E. Norton are seen in 1997 at their annual Easter lunch. Siblings Charles and Miki descend from early Italian settlers who arrived in Victorian Houston. Among the many ways Miki is involved in Houston are through the Friends of River Oaks Park, St. Anne's Catholic Church, River Oaks Baptist School, Kinkaid School, Society for the Performing Arts, Houston History Alliance, and Historic Hotels of America. Her husband, Dr. Norton, is a volunteer for Life Flight, an organization of private pilots who use their planes to fly for medical purposes, often saving lives. Dr. Norton flew patients, dogs, and monkeys trained to assist the disabled, as well as organs ready to be transplanted. In the 1992 image below, from left to right, Lawrence Lanowski, Stephen Lorch, Alexander Weaver, Michael Norton, and Ross Pollard are focused on sorting baseball cards at the Norton home on Troon Road. (Both, courtesy of Michaelene "Miki" Lusk Norton.)

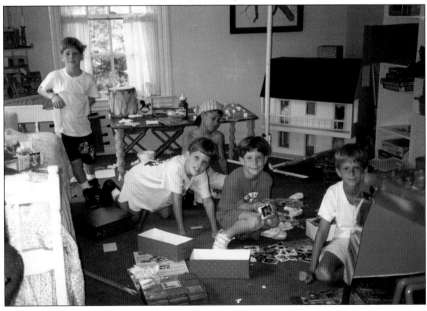

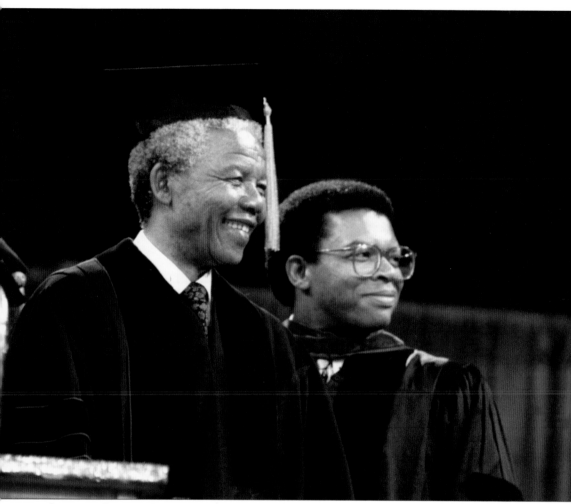

GREATEST LEADER. In 1991, as chairman of the Texas Southern University Board of Trustees, Rufus Cormier listened to stories from the freedom fighter Nelson Mandela while they waited for graduation to begin. Cormier said, "Mr. Mandela was one of the greatest leaders—if not the greatest leader—of the 20th century because he had such an influence on his country and the entire continent of Africa and, in fact, the entire world. It was one of the great honors of my life to be able to spend a few minutes with him and learn, on a personal basis, that he was one of the nicest, most humble, and most optimistic people I have had the honor of meeting." (Courtesy of Rufus Cormier.)

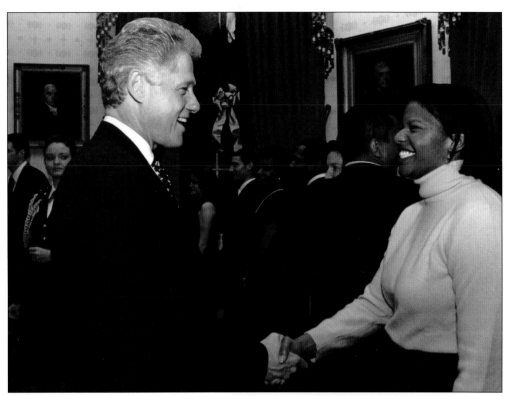

MICHELLE CORMIER. Pictured above, Michelle Cormier, the eldest child of Yvonne and Rufus Cormier, took time off from her studies at Princeton University to attend a White House reception for friends and supporters of Pres. Bill Clinton. Clinton and Rufus Cormier were classmates and remain friends. Michelle excelled at St. John's School (SJS), where she was an SJS "Lifer," meaning she attended St. John's kindergarten through senior year. After Princeton, she attended Yale University and served as editor of the *Yale Law Review*. In the photograph at right, taken at her River Oaks Country Club debut, Michelle enjoys a laugh with her maternal grandmother, Mildred Clements, a Beaumont English and French teacher. Michelle also had a love for languages and was proficient in Icelandic, Mandarin, German, Spanish, French, Greek, and Russian. (Both, courtesy of Rufus Cormier.)

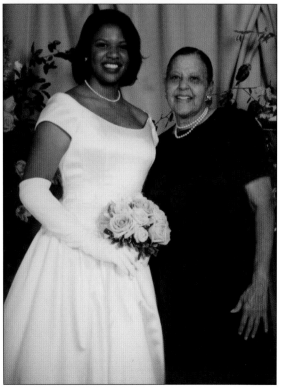

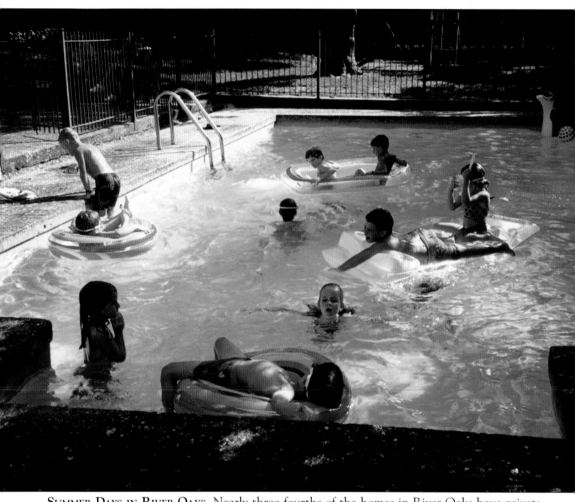

SUMMER DAYS IN RIVER OAKS. Nearly three fourths of the homes in River Oaks have private swimming pools, cabanas, and outdoor bathing facilities. This backyard on Troon Road was a cool destination for Norton family cousins and friends throughout the 1990s. (Courtesy of Michaelene "Miki" Lusk Norton.)

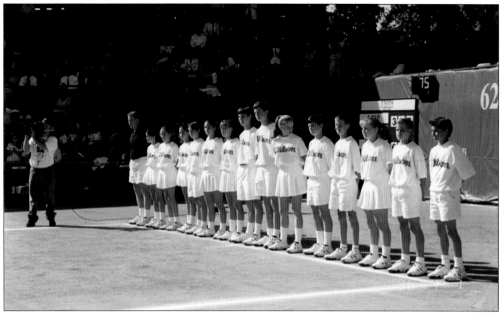

TO BE YOUNG IN RIVER OAKS. The River Oaks Tennis Tournament has taken place in this 3,000 wooden seat venue every year since 1931 (except during World War II). Youngsters over the age of 12 could meet a set of requirements to be a "ball kid," making the April tennis season etched in memory forever. The ball kids pictured here in the 1990s may have worked during encore performances by Bjorn Borg, Jimmy Connors, John McEnroe, or Boris Becker. Below, Michael Norton and friends, finished with sorting and dividing baseball cards, have ventured into his front yard to use pent-up energy. A common thread among longtime and recent River Oaks residents is the safety found in the neighborhood. (Both, courtesy of Michaelene "Miki" Lusk Norton.)

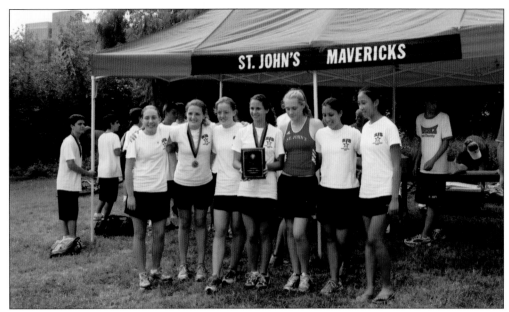

COMPETITION AND RECREATION. Founded in 1946, St. John's School is a member of Houston Area Independent Schools, the Southwest Preparatory Conference, and the Independent Schools Association of the Southwest. Pictured above, the St. John's cross country team is one of the luckiest in the city, in that they run the bayou and Memorial Park for practice. Given the large alumni base and supportive community, the St. John's Mavericks girls' cross country team had no shortage of parents and boosters willing to join the team in the early mornings at Memorial Park and along the bayou. These volunteers would go out before the girls and stand at the turns to make sure that everyone made it through safely. Pictured below is a River Oaks youth soccer team. (Both, courtesy of Joan Johnson.)

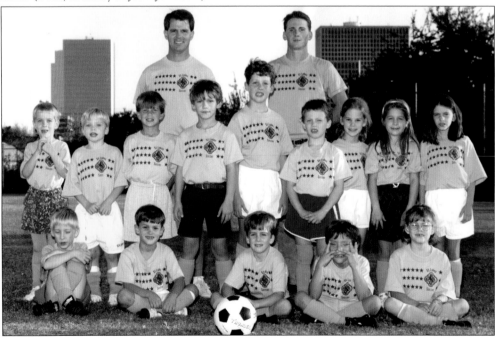

THREE GENERATIONS OF RIVER OAKS RESIDENTS. Luke Johnson stands tall between his mother (left) and grandmother Shirley Roach. The Roach and Johnson families were both in the automobile business and had homes in River Oaks. They were both members of River Oaks Country Club, Petroleum Club, and Houston Club. They were frequent patrons of the famed Isabelle Gerhart Clothing store, Esther Wolf's, and Wolfman's. Every Friday evening, everyone would congregate at the Del Monte Drive home of Luke and Joan Johnson to have dinner and visit with grandchildren and great-grandchildren. Leisure time was spent in Segovia, Texas, where Luke Johnson Sr. would fly them around in his King Air. Jack Roach and his son Luke Johnson had a Ford dealership. (Courtesy of Joan Johnson.)

DRESSING THE PART. The River Oaks Country Club dress code states: "All members and guests are to be suitably attired at all times while on Club premises. Gentlemen and boys over twelve years of age must wear coats in the Main Dining Room; gentlemen and boys over twelve, without coats or in athletic attire may be served in the Grill before 6:30 p.m. and all day Sunday, or in the Hunt Room or Hunt Room Terrace, and ladies in athletic attire may be served in either the Hunt Room or Hunt Room Terrace." Above, from left to right, Marion Minniece, Sue Trammell Whitfield, and Nancy Guest attend a fundraiser at the River Oaks Country Club. Below, Joanne Herring and the Baroness Sandra di Portonova are pictured at the River Oaks Country Club. (Both, courtesy of Stewart Morris Jr.)

A TRUE SOUTHERN LADY.
Joella and Stewart Morris
Sr. were patrons of Houston
Baptist University. Joella's
passion for history produced
the Museum of Southern
History at Houston Baptist
University, which was
part of the reason she and
Stewart Morris Sr. received
the Gordon Gray Award
from the National Trust
for Historic Preservation
in 1979. In addition to
history, Stewart Morris Sr.,
below, is among those in
Houston who count raising
horses among his passions,
remarking, "My horses
have always been grays as
people cannot see others at
night. Each horse knows his
name and responds to voice
commands. I know my horses
and keep each till death do
us part." (Both, courtesy
of Stewart Morris Jr.)

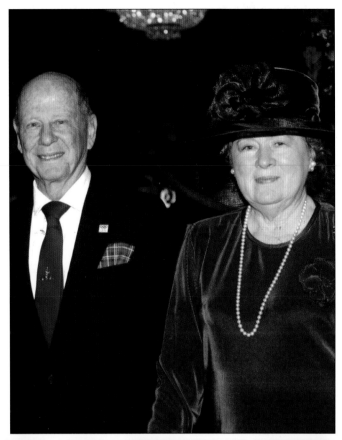

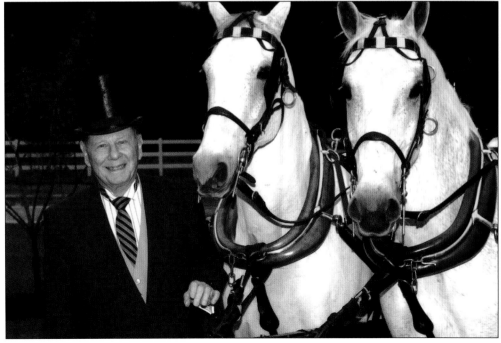

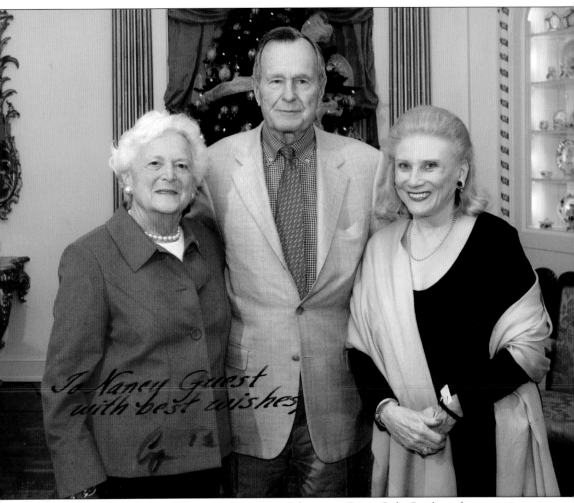

BALANCING FAMILY LIFE. Nancy and Jim Guest's home on River Oaks Boulevard was not just a great place to raise children, but also a great place to host the most distinguished of guests. Nancy is pictured here with Pres. George H.W. Bush and First Lady Barbara Bush. Jim Guest served with distinction in the Pacific during World War II, received a law degree from Harvard, came to Houston to practice law (where he found a calling in insurance), and chartered the Statesman National Life Insurance Company. During Christmastime, the Guest family held a traditional football game in the front yard using the huge oak and pine trees as end zones. As the Guest children started families of their own, eventually all 13 grandchildren would come back to play in these football games. (Courtesy of Nancy Guest.)

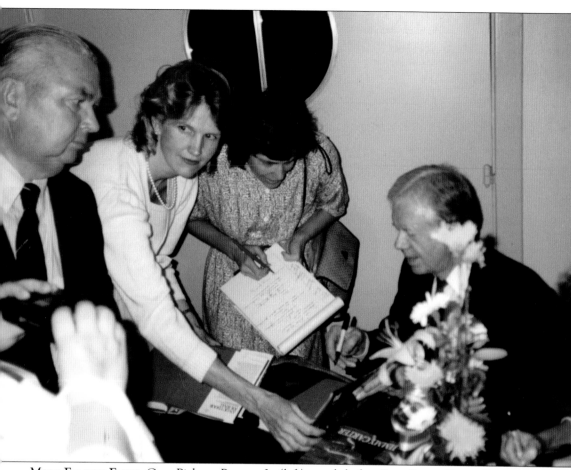

MORE FAMOUS FACES. Gary Pickney Pearson Jr. (left) stands before Pres. Jimmy Carter. Pearson was in the Texas legislature for six years, served with the US Navy in the South Pacific during World War II, and was commended for bravery on Iwo Jima. His wife, Mary Bain Haralson Pearson, was in the national spotlight when she testified at the congressional hearings on Enron. They asked her what she did for a living, and she said, "I'm just a little old Latin teacher. A pebble in the stream in the Enron litigation." (Courtesy of Mary Bain Pearson.)

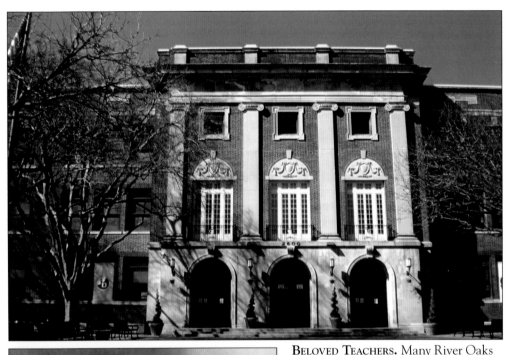

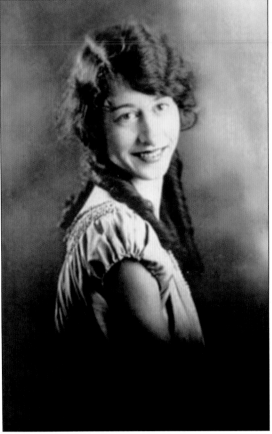

BELOVED TEACHERS. Many River Oaks residents remember Aletha Marshall (left) who taught girl's physical education in the Houston Independent School District for 39 years. She was at Lanier Junior High (above) for 17 years and went with some other teachers from there to open the new T.H. Rogers Junior High, where she stayed five years and retired. She was the head of the department, cheerleader sponsor, and in charge of dance routines for May Fetes. She taught volleyball, deck tennis, softball, health, and dancing. To this day, there are lifelong residents of River Oaks who can still tap dance to "Three Blind Mice" thanks to Aletha. Lanier Middle School was opened as Sidney Lanier in 1926 and changed to Bob Lanier in 2016. (Above, courtesy of Joan Johnson; left, courtesy of SallyKate Marshall Weems.)

COUNTRY CLUB AT BOTH ENDS. Seen above, local residents sometimes refer to Lamar High School as the country club at the other end of River Oaks Boulevard from River Oaks Country Club. When Lamar opened in 1937, Westheimer Road was not yet paved, and only 10 percent of its students lived in the River Oaks subdivision. Lamar High School has fostered amazing talents like actors Tommy Tune and Robert Foxworth, singer Kelly Rowland, and artist Jack Boynton. Below, at the Lamar 50th anniversary, from left to right, Miki Lusk Norton, Bess Baker Wilson, Sherry Spradley Holmes, Charlene Lusk Dwyer, and Sallie Gardner Schillaci reunite on Lamar's front lawn. During their time as singers with the Lamar High School Choralettes, they enjoyed daily brown bag lunches on the lawn under the live oak trees of Lamar's campus. (Both, courtesy of Michaelene "Miki" Lusk Norton.)

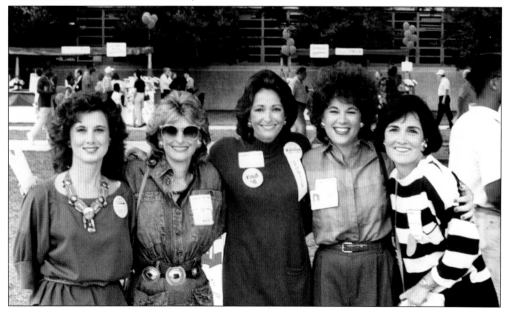

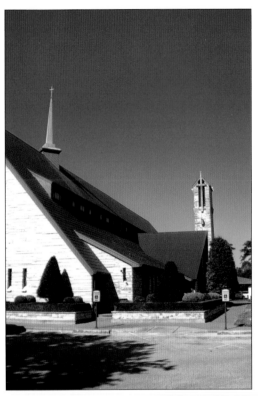

Worship. In August 1940, the Right Reverend Clinton S. Quin, the Reverend Charles Sumners, and his twin brother, the Reverend Thomas Sumners held the ground-breaking ceremony for the construction of St. John the Divine Church. Hugh Potter and the River Oaks Corporation were very supportive. On June 10, 1942, Sumners wrote a letter to Hugh Potter which read, "I want to thank you, Hugh, for your understanding of my plan for the future of the Church in this community. It's just an extension of your own vision of a community of homes and schools." The first services were held in the stone chapel seen below. (Both, courtesy of Michael Flores Photography.)

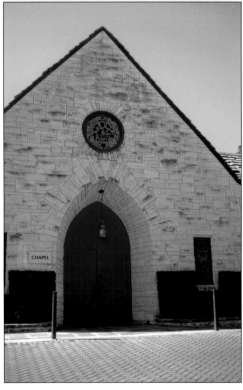

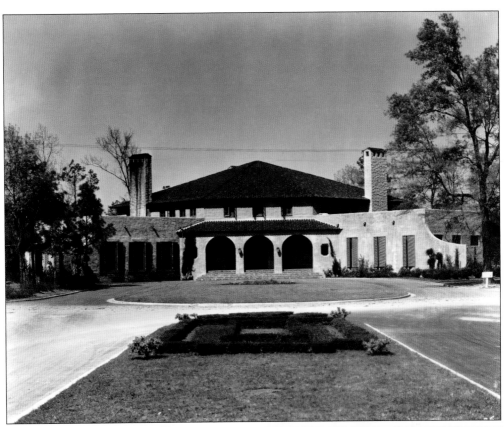

RIVER OAKS COUNTRY CLUB THEN AND NOW. Above is the original design of River Oaks Country Club in Spanish Revival style, as designed by John Staub in 1923 for Tom Ball, T.W. House, and A.C. Guthrie. The current style of the club, seen at right, reflects the renovations carried out in the 1990s by Gensler and Associates. (Above, copyright Story Sloane's Gallery; right, courtesy of Michael Flores Photography.)

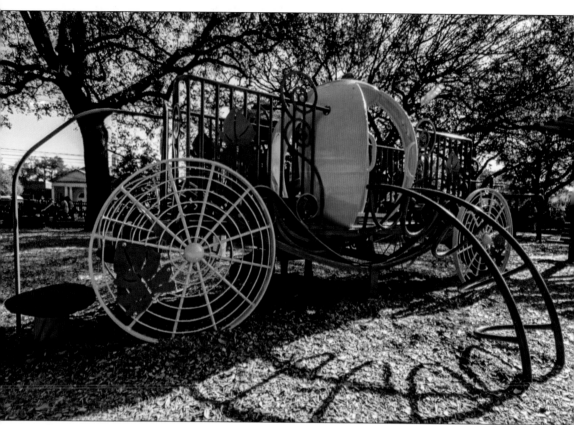

PUMPKIN PARK. River Oaks residents affectionately refer to this playground equipment as "Pumpkin Park." In 1938, this area in the heart of the subdivision was left open by the developers for later public use. Those of the right age interviewed for this book had hours and hours of stories from the 1940s on of time spent playing with friends and family there. Seventy years later, there is still a community on Facebook that commemorates the history of the park and routinely raises funds to upgrade the park, with a serious upgrade and ribbon-cutting ceremony taking place in March 2016. (Courtesy of Joan Johnson.)

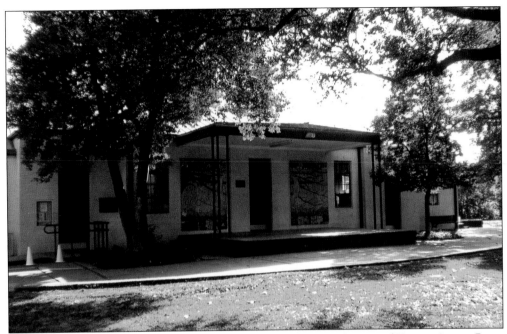

PARKS IN RIVER OAKS. For the nine to ten months of warm weather out of Houston's year, River Oaks can seem like one big garden party. One of the ways in which the River Oaks Corporation created this feeling when the subdivision was built was through the use of public park space following the same design restrictions as the houses. This historic community center building in the multi-acre Pumpkin Park was designed by John Staub. Below, Ella Lee Park was established in 1937, and in 2006, the Rutherford family donated time and money to beautify the area with bushes, flower beds, and seating areas. (Above, courtesy of Joan Johnson; below, courtesy of Michael Flores Photography.)

THE STREETS OF RIVER OAKS. River Oaks was designed as a residential subdivision winding below Buffalo Bayou, laid out in such a way as to keep the streets flowing in a rhythmic meander. The streets closest to the River Oaks Country Club, all named for famous golf courses, were some of the first developed by the River Oaks Corporation. These photographs, taken in 2016 by talented photographer Michael Flores, capture the current view of the expansive nature of River Oaks structures and the acreage upon which they are built. (Both, courtesy of Michael Flores Photography.)

Three

2000–2016

Today, River Oaks is home to not just oil barons, but doctors, lawyers, real estate executives, software engineers, mortgage bankers, and celebrities. River Oaks has changed since the millennium just as the rest of the world has, but also, as the saying goes, "The more things change, the more things stay the same."

Although the influential faces that called River Oaks home in its inception and through the 20th century may not all still be there, that does not mean that as a community, it wields any less influence. Recessions, the dot-com bubble, and a plummet in oil prices in the mid-2010s were all felt as acutely in Houston as anywhere else in the country. Many of the families who have lived in River Oaks for generations continue to, and due to the aspirational nature of the neighborhood, there are always new families moving in. Just because the parks where the children would play do not bear all the same names and host all the same games does not mean that the children's laughter is not as loud. Just because some families have moved out and some have moved in does not mean that the newest family on the block is not looking for the exact same thing that the first wave of families was looking for.

In its inception in the 20th century, and in the recent past, River Oaks continues to excel at being what anyone wants out of their neighborhood: a place to raise a happy family and build a hefty fortune.

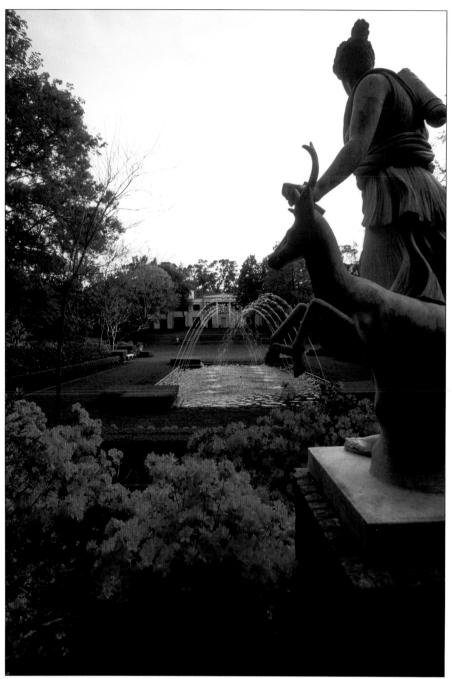

THE DIANA GARDEN AT BAYOU BEND. A world-class art collector with an acute sense for aesthetics, Ima Hogg hired Fleming and Sheppert, with the help of designer Ellen Shipman, to create the terraced north garden of Bayou Bend between 1938 and 1939. Grass-covered steps lead to a rectangular reflecting pool with fountain jets spraying an arc. In the right sunlight, the jets make a rainbow that crowns the marble statue of the Roman goddess of the harvest Diana. Profits from fundraising by the River Oaks Garden Club help maintain the gardens at Bayou Bend. (Courtesy of Jim Olive Photography.)

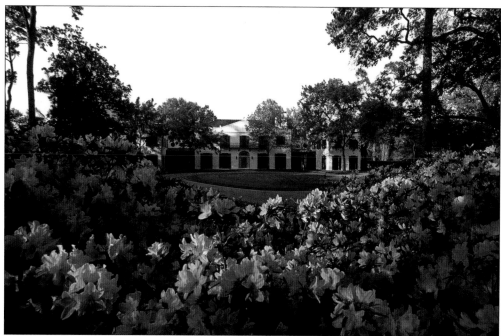

A GREAT HOUSTONIAN.
(Although built by Ima Hogg
a century earlier and opened
to the public in 1966, it was
1999 that saw Bayou Bend,
seen above, become an official
historical landmark in the
city of Houston. Pictured at
right, Ima Hogg was the only
daughter of famous governor
of Texas James Hogg and came
to be known as "the first lady
of Texas" after the death of
her mother. She was one of
the main benefactors of Bayou
Bend, which sits on 14 acres
of land in River Oaks and
has 27 rooms. Many of those
rooms have been open to the
public for guided tours for some
time now and are decorated
every Christmas according to
the traditions of bygone eras.
(Above, courtesy of Jim Olive
Photography; right, courtesy
of San Jacinto Museum.)

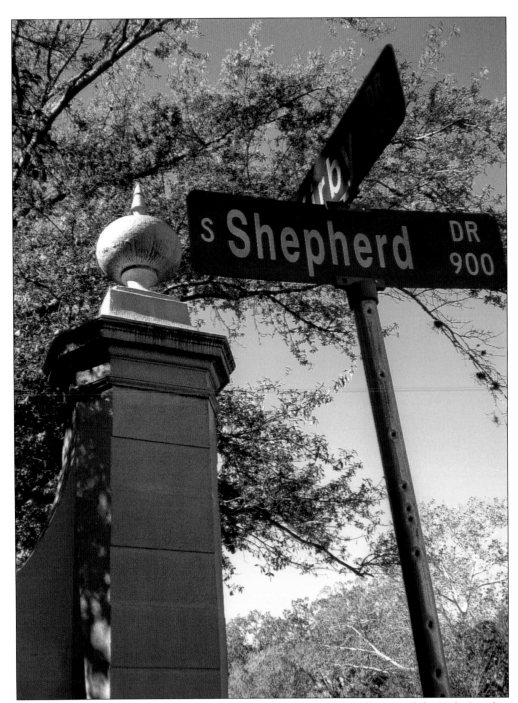

SHEPHERD AT KIRBY. Kirby Drive was named for John Henry Kirby, who owned the Kirby Lumber Company. At its peak, Kirby Lumber employed 16,500 people between five logging camps and included 12 operating mills. Shepherd Drive is named for David P. Shepherd, the superintendent at the Southwest Telegraph Company. He built a dam on Buffalo Bayou in preparation for a gristmill and flour mill. Financial problems wrecked the plan, but Shepherd's Dam and its impounded water became a popular swimming hole. (Courtesy of Joan Johnson.)

RIVER OAKS AMENITIES. Since 1937, the River Oaks Shopping Center has served residents with businesses that reveal the changing needs and desires of their customers. In the earliest days, the Camilla Anne Dress shop touted these advantages: "The shop is air cooled and spacious, lined with mirrors and carpeted with soft restful blue." Other early occupants were the Arthur Murray dance studio and the Palladium bowling alley. These photographs taken in 2016 reveal the likes and interests of today's residents. A few of these establishments have serviced the River Oaks area for many years, such as the River Oaks Bookstore owned by Jeanne Jard. (Both, courtesy of Michael Flores Photography.)

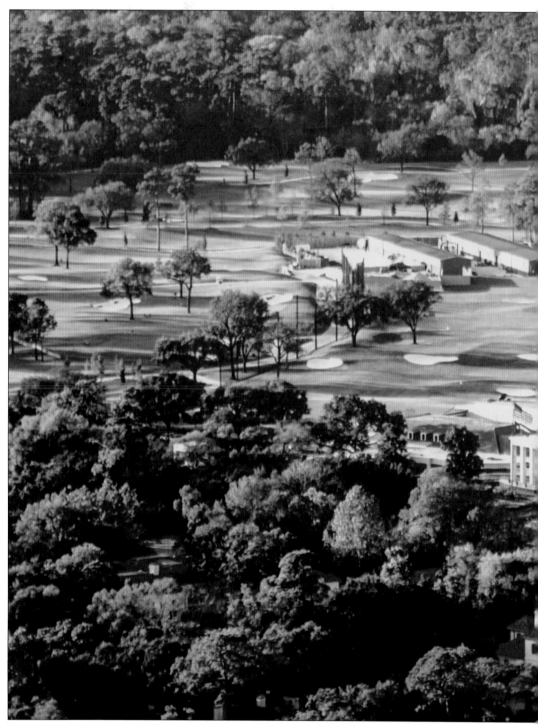

FROM THE HEAVENS. This is a view of River Oaks Country Club in the fall of 2015 from the Huntingdon High Rise. The standard design in River Oaks was a central street lined with house sites. The River Oaks subdivision was built around the golf course, classified as "both public and private, with occupied and restricted private residences." Some of the first residents were golf

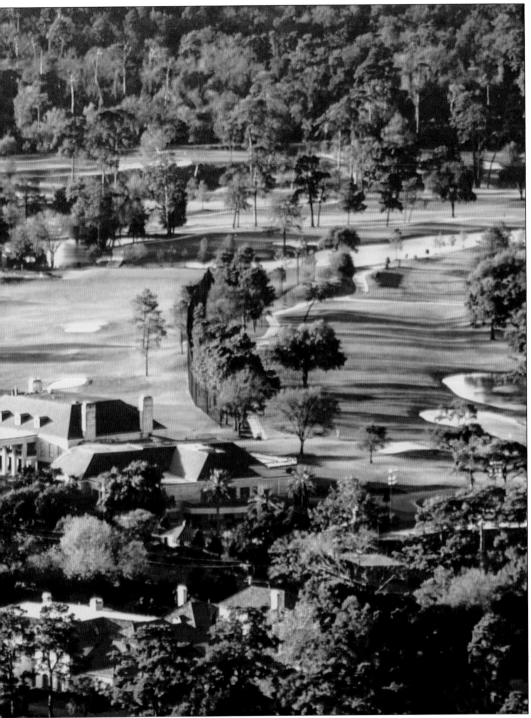

enthusiasts who joined the country club and then bought lots nearby. The first homes in the area, built as speculative homes by the River Oaks Corporation, slowly gained popularity and were occupied by the 1930s. (Courtesy of Michael Flores Photography.)

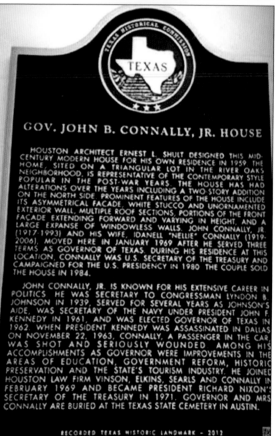

GOV. JOHN B. CONNALLY, JR. HOUSE

HOUSTON ARCHITECT ERNEST L. SHULT DESIGNED THIS MID-
CENTURY MODERN HOUSE FOR HIS OWN RESIDENCE IN 1959. THE
HOME, SITED ON A TRIANGULAR LOT IN THE RIVER OAKS
NEIGHBORHOOD, IS REPRESENTATIVE OF THE CONTEMPORARY STYLE
POPULAR IN THE POST-WAR YEARS. THE HOUSE HAS HAD
ALTERATIONS OVER THE YEARS INCLUDING A TWO-STORY ADDITION
ON THE NORTH SIDE. PROMINENT FEATURES OF THE HOUSE INCLUDE
ITS ASYMMETRICAL FACADE, WHITE STUCCO AND UNORNAMENTED
EXTERIOR WALL, MULTIPLE ROOF SECTIONS, PORTIONS OF THE FRONT
FACADE EXTENDING FORWARD AND VARYING IN HEIGHT, AND A
LARGE EXPANSE OF WINDOWLESS WALLS. JOHN CONNALLY, JR.
(1917-1993) AND HIS WIFE, IDANELL "NELLIE" CONNALLY (1919-
2006), MOVED HERE IN JANUARY 1969 AFTER HE SERVED THREE
TERMS AS GOVERNOR OF TEXAS. DURING HIS RESIDENCE AT THIS
LOCATION, CONNALLY WAS U.S. SECRETARY OF THE TREASURY AND
CAMPAIGNED FOR THE U.S. PRESIDENCY IN 1980. THE COUPLE SOLD
THE HOUSE IN 1984.

JOHN CONNALLY, JR. IS KNOWN FOR HIS EXTENSIVE CAREER IN
POLITICS. HE WAS SECRETARY TO CONGRESSMAN LYNDON B.
JOHNSON IN 1939, SERVED FOR SEVERAL YEARS AS JOHNSON'S
AIDE, WAS SECRETARY OF THE NAVY UNDER PRESIDENT JOHN F.
KENNEDY IN 1961, AND WAS ELECTED GOVERNOR OF TEXAS IN
1962. WHEN PRESIDENT KENNEDY WAS ASSASSINATED IN DALLAS
ON NOVEMBER 22, 1963, CONNALLY, A PASSENGER IN THE CAR,
WAS SHOT AND SERIOUSLY WOUNDED. AMONG HIS
ACCOMPLISHMENTS AS GOVERNOR WERE IMPROVEMENTS IN THE
AREAS OF EDUCATION, GOVERNMENT REFORM, HISTORIC
PRESERVATION AND THE STATE'S TOURISM INDUSTRY. HE JOINED
HOUSTON LAW FIRM VINSON, ELKINS, SEARLS AND CONNALLY IN
FEBRUARY 1969 AND BECAME PRESIDENT RICHARD NIXON'S
SECRETARY OF THE TREASURY IN 1971. GOVERNOR AND MRS.
CONNALLY ARE BURIED AT THE TEXAS STATE CEMETERY IN AUSTIN.

RECORDED TEXAS HISTORIC LANDMARK - 2012
MARKER IS PROPERTY OF THE STATE OF TEXAS

A GOVERNOR ON RIVER OAKS BOULEVARD. This modern house was built in 1959 by architect Ernest L. Shult as his own residence. Ten years later, Texas governor John B. Connally Jr. and his wife, Nellie, moved into this River Oaks Boulevard home from the governor's mansion in Austin. Terrell, Texas, native Kaye Horn bought this home in 2010. Within two years of purchasing it, Horn applied for, sponsored, and received an official Texas state historical marker. (Both, courtesy of Kaye Horn.)

ENCOURAGING WORLD CHAMPIONS.
Pictured above, Kaye Horn is known
for applauding outstanding youth, as
evidenced by her dedication to Texas
A&M University, the United Way, and
Gulf Coast Mensa. Horn and Texas
A&M graduate Mary Becker enjoyed an
elegant evening saluting the Olympic
contender Simone Biles. Visitors to
Horn's River Oaks Boulevard home
enjoyed the open, modern setting
adorned with exquisite artwork. At right,
Kaye Horn displays this reproduction
of Italian artist Gian Lorenzo Bernini's
The Rape of Proserpina in her home.
This is one of Bernini's most famous
works, with the original being in the
Galleria Borghese. (Both, courtesy
of Michael Flores Photography.)

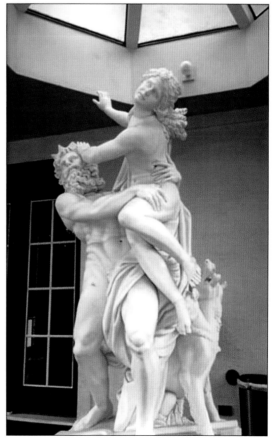

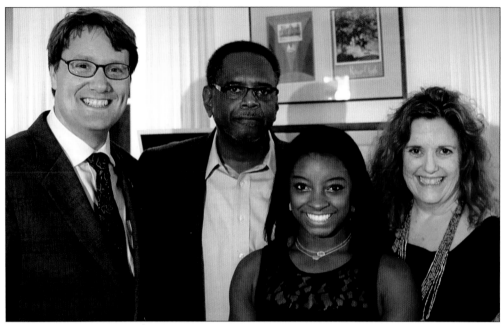

SIMPLY A NATURAL. At six, Simone Biles was just playing around, imitating gymnasts. She was noticed by a coach who then sent a letter inviting her to join the class. Since then, Biles has become the three-time all around world champion. She is a favorite in the 2016 Summer Olympics in Rio de Janeiro. Kaye Horn told Shelby Hodge with CultureMap, "Biles accomplishments will encourage others to succeed and she handles her notoriety with grace and kindness. She is a tiny, fearless exemplar of girl power. A wonderful role model for women everywhere." Above, Jonathan Sandys (far left), and writer Ann Becker (far right) pose with Simone and her father, Ron Biles. Below, Simone Biles poses with fan Raquell Riddell and lifelong gymnast and fan Andrea Zimmer. (Both, courtesy of Kaye Horn.)

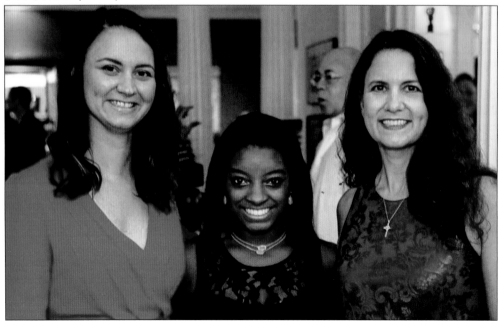

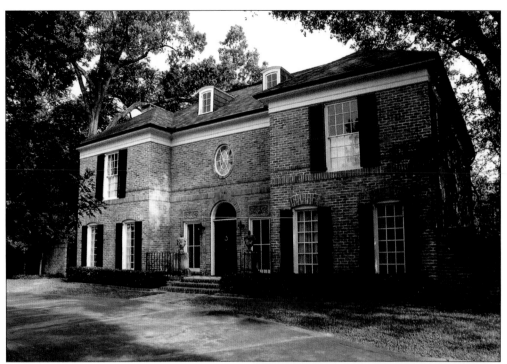

DEL MONTE DRIVE. Streets closest to the River Oaks Country Club in the section called Country Club Estates were named for famous golf courses like Inwood, Chevy Chase, and Del Monte in Monterrey, California. The home above on Del Monte Drive was built in the 1930s and purchased in 1994 by Luke and Joan Johnson. The pool is a Thompson and Hansen pool designed as a cocktail or plunge pool. At right, Lauren Ballew (left) and Maria Becker Troegel admire the landscaping and pool during an event promoting the book *Houston's River Oaks*. (Both, courtesy of Joan Johnson.)

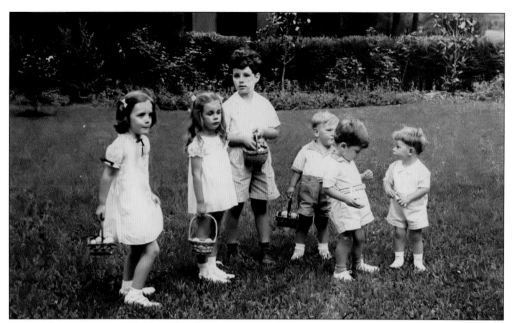

RIVER OAKS 1923 TO TODAY. Buying property in River Oaks was slow to catch on until the 1930s, when families began to move in and the River Oaks Corporation developed more of the 1,100 acres. Above, six grandchildren participate in an Easter egg hunt in the spring of 1939 at E.E. Townes's home on Chevy Chase Drive. Several of these children, now adults, still live in their beloved River Oaks. From left to right are Mary Louise Townes (Reba Drive) Aileen Townes (Banks Street), Paul Pressler (Pine Valley Drive), Goss Townes (Reba Drive), Townes Pressler (Pine Valley Drive) and Charles Townes (Banks Street). Pictured below in 2012, Judge Paul Pressler and Joan Johnson reminisce at Johnson's home on Del Monte Drive. Memories of an idyllic childhood were shared among the guests. (Above, courtesy of Judge Paul Pressler; below, courtesy of Jim Fisher.)

THE GREATEST HONOR, FATHER OF THE YEAR. At right, Rufus Cormier (far left) is pictured at a gala benefiting the nonprofit Community Partners. He was one of the men pictured receiving father of the year. Also pictured are Gene McDavid, then president of the *Houston Chronicle*, and former NFL player Ray Childress. Below, Cormier celebrates with, from left to right, Geoffrey, Claire, and Michelle Cormier. (Both, courtesy of Rufus Cormier.)

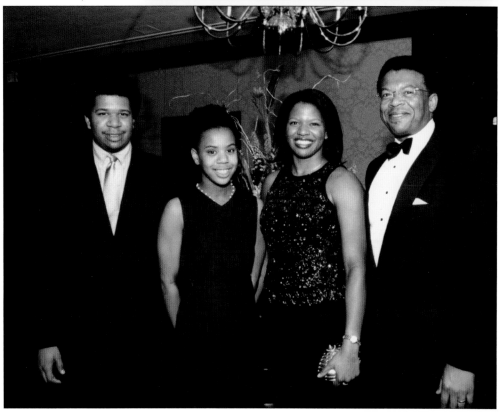

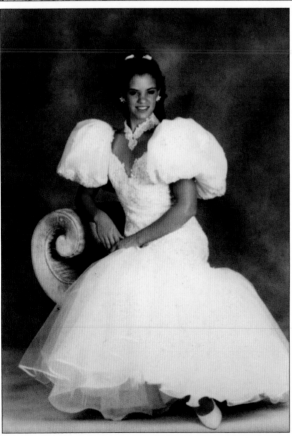

PICTURE PERFECT IN BOTH WORLDS. Above, Hydie McAlister prepares to saddle up. In regard to the image at left, McAlister remembers, "This debutante dress holds very special memories. I wore it twice, once at the River Oak Country Club Debutante party and again at the International Debutante Party in New York City. I had to do a full 'Texas Dip' curtsy in this dress in the middle of the Waldorf Astoria ballroom, which was full of hundreds of people." Houstonian Ann Haugen, who is one of two American ambassadors to Queen Charlotte's Ball in London, described the famous Texas Dip, which when done right is as graceful as a swan. The debutante sits on her feet, folds over, and touches her nose to the floor. It requires hours of practice to perfect. (Both, courtesy of Rhetta Moody McAlister.)

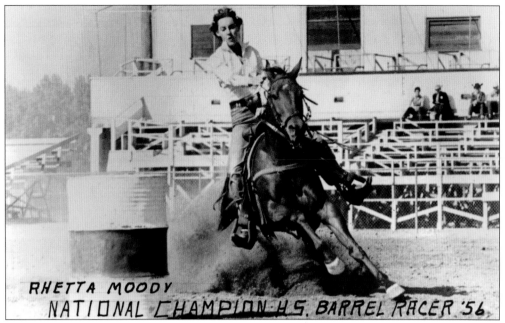

RHETTA MOODY
NATIONAL CHAMPION H.S. BARREL RACER '56

A FAMILY LOVE OF HORSES. Rhetta Moody McAlister grew up on Chilton Road. Her father, Denman Moody, was a senior partner at the Baker Botts law firm, in charge of litigation. A dedicated horsewoman, Rhetta won the national championship in barrel racing in 1956. Her husband, Jim McAlister, was raised in Louisiana and arrived in Houston to complete a master's degree in engineering and business at the University of Houston. When they married, Jim had never been around horses, while Rhetta was raised in the saddle. At the Denman Moody Ranch, in Rocksprings, Texas, Jim soon adopted his wife's passion and was the Buckskin Reserve world champion in reining one year. (Both, courtesy of Rhetta Moody McAlister.)

CINDERELLA AND HER CARRIAGE. In 2014, this horse and carriage is being driven to the River Oaks Country Club filled with anxious debutantes. Debutante tradition is carried down through families as a rite of passage, and the horse-drawn carriage illustrates the stately tradition of this lovely occasion. Debutante balls are held all over the United States and abroad. Ann Haugen explained, "Queen Charlotte's [debutante ball] in London raises money for cancer charities and

children's charities. The National Debutante Cotillion and Thanksgiving Ball of Washington has raised over a million dollars for the Children's Hospital of Washington, DC." (Courtesy of Susan Muncey.)

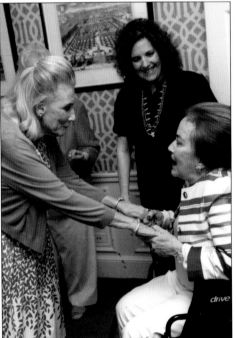

Debutantes in Three Generations. A debutante season includes many lovely parties given by each of the celebrating families. In 2014, the Vosko family gave a tea at the River Oaks Country Club in honor of their daughter. The event included scrumptious food and live music. At left, grandmother of the debutante Nancy Guest (left) was delighted to see her longtime friend Sue Trammell Whitfield arrive with writer Ann Becker. Seen above in 2015, Katherine Vosko, her escort Brooks Barclay, and Lumdy Porter attend the pre-ball party held at realtor George Murray's home on Huntingdon Street. Katherine's mother Gina Guest Vosko was also a debutante, as was her sister Rhonda Barclay. (Courtesy of Gina Vosko.)

EAGERLY AWAITING THEIR DATES. The pre-ball party is as exciting as the evening itself. Seen above at a house on Huntingdon Street, escorts await the arrival of their dates by car or carriage. Inside the house, a large dining room table with polished silver and amazing food welcomes the excited celebrants. Below, an elegant pre-ball party sets the mood for the carriage ride up River Oaks Boulevard to the elevated circular drive at the entry. The entire evening is splendid. (Courtesy of Joan Johnson.)

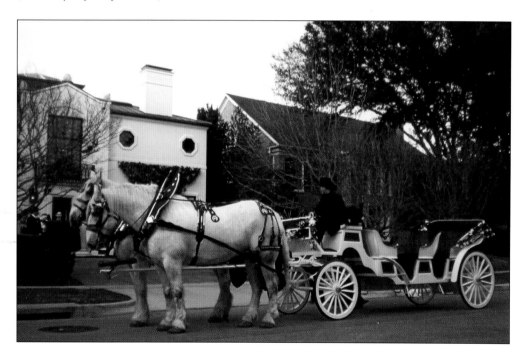

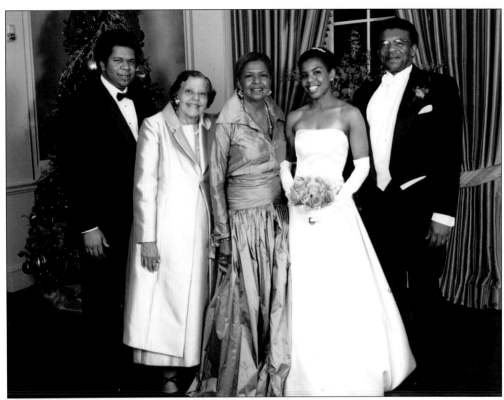

RIVER OAKS COUNTRY CLUB. Claire Cormier has fond memories of her debut. "The entire debut season was such an incredible experience, filled with nearly three weeks of formal silver service teas in the mornings, debutante luncheons at midday, and black tie parties each night. Returning from college, it was a treat to be back with childhood friends, neighbors, and classmates, catching up on our lives, comparing sorority rituals, as we practiced our steps and Texas bows." At left, Rufus Cormier is pictured with his mother, Katie Cormier (then 93 years old), at the 2004 luncheon where Rufus received the Anti-Defamation League's Karen H. Susman Jurisprudence Award. Born in Cheneyville, Louisiana, Katie Elbert Cormier lived in Galveston, and finally Beaumont, where she ran a small family grocery store. Rufus remembers, "She was a sweet, sensitive, hardworking, deeply religious woman, and the most wonderful mother one could hope to have". (Both, courtesy of Rufus Cormier.)

The Azalea Trail. In 1927, the River Oaks Garden Club was established. For the next eight years, they worked tirelessly, and by 1935, they held their first Garden Pilgrimage. It soon became known as the Azalea Trail and is held during the spring season when the azaleas are in bloom. The Bayou Bend Gardens, Rienzi, and the Forum of Civics are usually on the trail, along with three to four private homes. (Courtesy of Joan Johnson)

AZALEA TRAIL HISTORY. Since 2006, Houston has been an "Azalea City," at least according to the River Oaks Garden Club. Houstonians come from all over to follow the Azalea trail, learning about flower arrangements, horticulture in the Houston area, and different architectural styles. The proceeds from those who come are reinvested back into the community. Historically, they

have been used to landscape the entrance to Bayou Bend on Westcott, Tranquility Park, Discovery Green, River Oaks Elementary, and the area along Allen Parkway near Shepherd Drive. (Courtesy of Jim Olive Photography.)

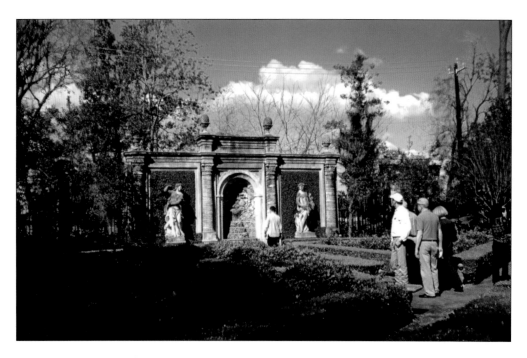

PRIVATE HOMES ON THE TRAIL. In 2016, a private home opened its doors, revealing these long stone walls with concrete statues. Some of the homes in River Oaks are on eight acres of land professionally landscaped to perfection. This home on Inwood Drive was known as "the Castle" by a younger generation and has for years been a destination for fundraising that benefits Houston establishments such as the Houston Public Library. (Both, courtesy of Joan Johnson.)

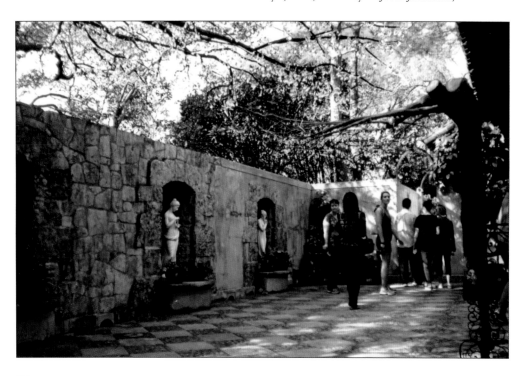

GENERATIONS ON THE TRAIL. Pictured here are Kaleta and Seth Johnson on the Azalea Trail. Fourth-generation River Oaks resident Seth returned to live in the subdivision after serving in the armed forces. Kaleta went to Pooh Corner and Kinkaid, and then graduated from St. John's after 13 years. Like Claire Cormier and many other young River Oaks residents, this made her an SJS "Lifer." She attended Raymond Walsh School of Foreign Affairs and graduated with honors from Georgetown University. Currently living in Dallas, she visits her Houston family often and never misses a chance to enjoy the annual Azalea Trail. (Courtesy of Joan Johnson.)

HEAVENLY GATES. Bain Pearson Pitts comments, "We bought the lot adjoining our home about four years ago. I enjoyed designing and landscaping this beautiful garden with seven fountains and three fire pits. We have created a wonderful flow for parties from our garden into our home. Dale, my husband, and I were looking to buy a home and while at the beauty parlor, my mother heard about the sale of this house. She called me immediately, and we went over to the house, walked around it, got the realtor on the phone, and we went in to it and said 'yes, we'd buy it.' There were already three contracts on it, but they all fell through, and we got it."

YEARS OF FAMILY GET-TOGETHERS. All grown up, the Pearson men—Gary and Jim—stand in front of a painting that has hung above the fireplace in their Olympia Drive home since they were children. These men appeared on page 22 sitting with sister Bain in front of the Christmas tree in the 1970s. This painting can be seen in the picture behind the tree and continues to hold the mantel place of honor in the home where their mother Mary Bain continues to reside. Their parents kept their children close, and today, on any given Sunday, the entire extended family enjoys brunch at the Avalon Café. (Courtesy of Mary Bain Pearson.)

ACTIVE HOUSTONIANS. Pictured above, Bain and John Pitts are active community leaders who host all kinds of parties for charitable, political, and social causes. In 2005, after 110 years, the Houston Club appointed Bain as its first woman president. Seen at left in 2015, Bain receives the Sue Trammell Whitfield Award for Resiliency. Philanthropist Sue Whitfield, a former River Oaks resident, follows the lead of her grandmother Ella Cochrum Fondren in continuing to support the success of Houston's Medical Center and the Woman's Fund. In 2007, the Health Museum opened the Sue Trammell Whitfield Gallery, a 6,000-square-foot space where traveling exhibits from around the country are displayed. (Both, courtesy of Bain Pearson Pitts.)

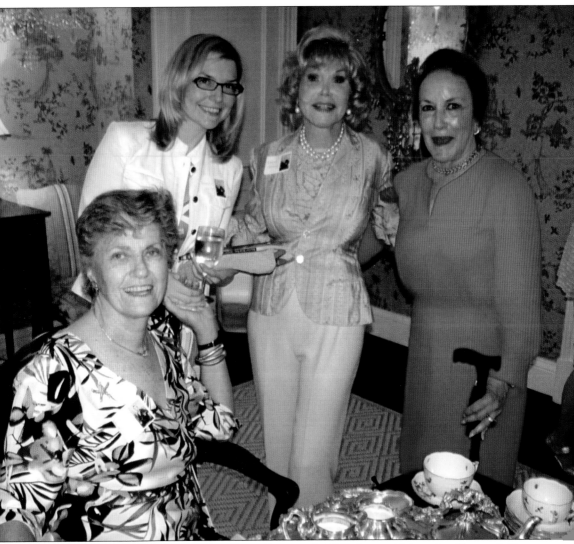

REUNION AT HOUSTON'S RIVER OAKS BOOK SIGNING. In 2012, Images of America: *Houston's River Oaks* was published, and an elegant reception was held by Sarah Rothermel Duncan at resident George Murray's exquisite home on Huntingdon. In this picture are three longtime friends: seated is Catherine "Trinka" Blaffer Taylor of Dallas, with Joanne King Herring (center) and Sue Trammell Whitfield. These women have been part of the River Oaks scene and have given much of their time and philanthropy to Houston. (Courtesy of Mary A. Becker.)

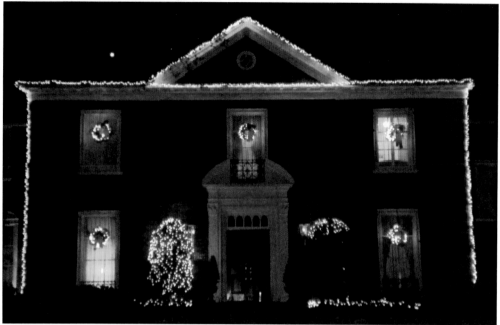

RIVER OAKS AT CHRISTMASTIME Aside from the name recognition, possibly the thing River Oaks is most famous for to other Houstonians is the splendid display put up every Christmas. The residents of River Oaks simply go all out in an effort to literally light up the entire neighborhood with Christmas cheer. The bills for the contractors who set up these lights can run in the tens of thousands of dollars, but no expense is spared, as people from all over the city have made it a tradition to drive up and down the streets of River Oaks to take pictures and admire the lights. (Courtesy of Joan Johnson.)

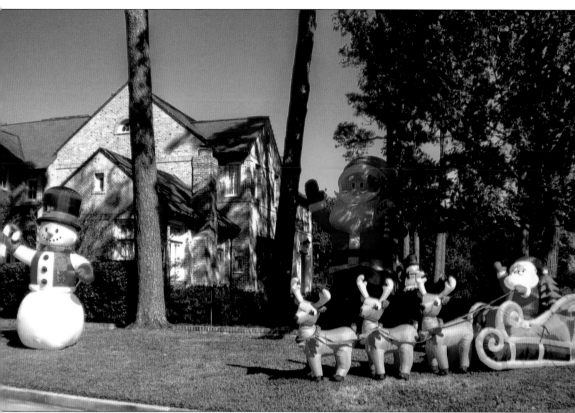

CHRISTMAS IN THE DAY. Not every Christmas display is only for the nighttime, such as the large, inflatable Christmas figures seen in this River Oaks front yard. When interviewed, many of the residents in River Oaks said they thoroughly enjoyed the decorations that went up at Christmastime, and that it could sometimes even get competitive, although it was all in the spirit of the holidays. (Courtesy of Joan Johnson.)

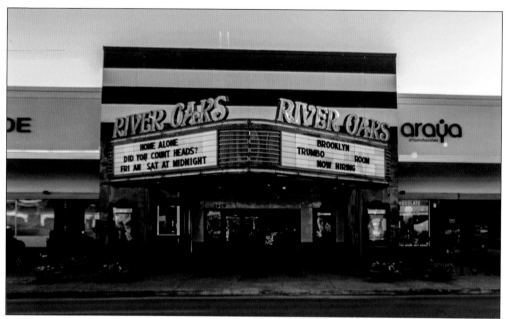

A NAME THAT SPEAKS FOR ITSELF. Located in the Neartown neighborhood adjacent to River Oaks, the River Oaks Theatre has been a landmark and fixture in the lives of River Oaks residents throughout its life. It offers a fantastic case study on a changing neighborhood. On any given day, one could find young families enjoying a movie in the afternoon, but just as popular (if not more so) are raucous showings of cult films like *The Rocky Horror Picture Show* at midnight on the weekends. Indeed, there is something for almost everyone at River Oaks Theatre, which is why residents of River Oaks and elsewhere continue to keep it afloat through patronage and fundraising. Pictured below is River Oaks Donuts, which has become as much a part of the River Oaks breakfast scene as its owners, Mindy and Jeffery Hildebrand (founder of Hilcorp), are a part of the River Oaks social scene. (Both, courtesy of Michael Flores Photography.)

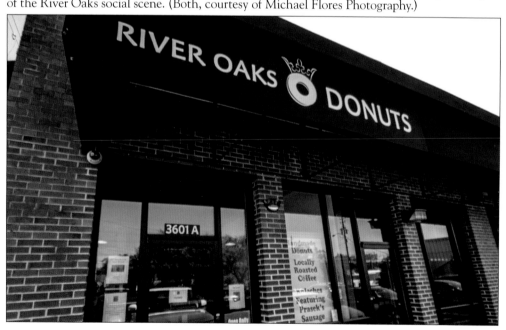

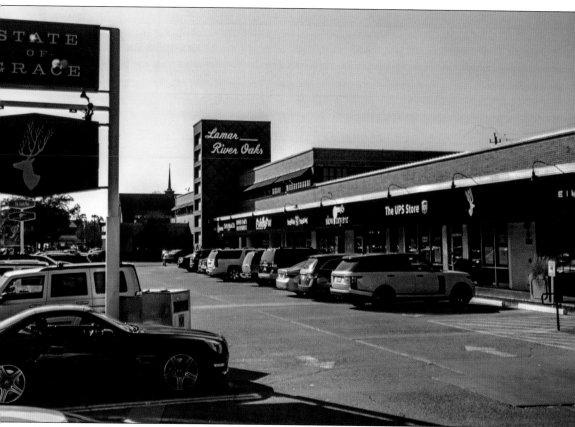

SOMETHING NEW AND FAMILIAR Andre's, a small French restaurant, sat along Westheimer Road at the end of River Oaks Boulevard for many years as a resident and critics' favorite. Many were sad to see it go, as it was not only a great place to clink aperitifs and say, "bon appetite," but it was also a River Oaks institution. In 2015, chef Ford Fry opened State of Grace to much acclaim, earning Restaurant of the Year from Eater Houston after only one month of being open. As if an answer to those who want a new Houston institution, State of Grace explains that even where "the modern world churns, here is a place where life slows down, stops, and takes us back through memory." (Courtesy of Joan Johnson.)

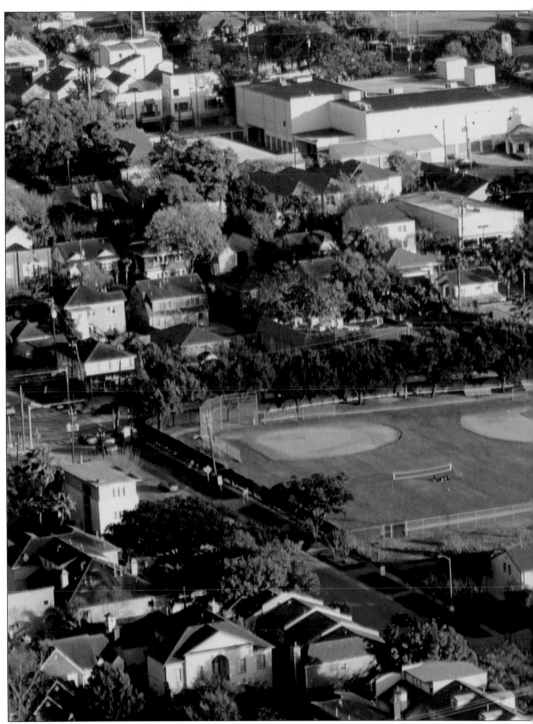

From the very beginning, the founders of River Oaks provided the necessities for a family-oriented subdivision. This planning included multiple parks platted among the various sizes of residential lots and intricate design of the amenities of these playgrounds. The River Oaks Corporation also made sure that schools were located close, and of course, of foremost importance were houses of

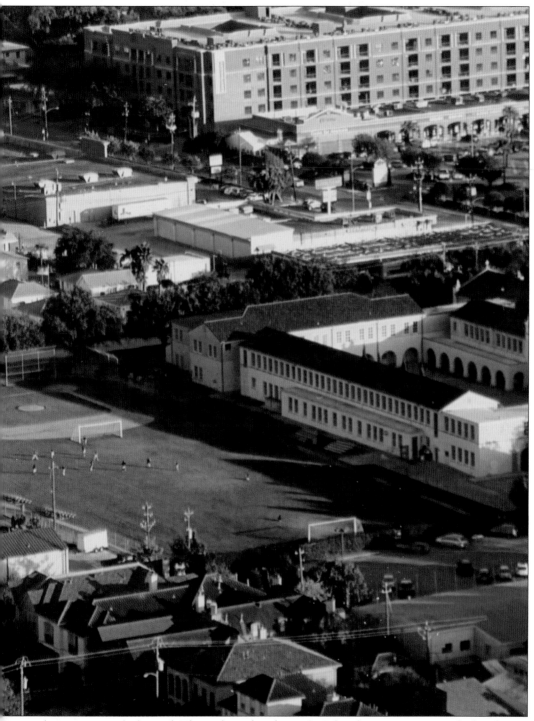

religion to nourish the soul. The earliest church was St. John the Divine Episcopal Church, and the first Catholic church was not far behind. Both of these establishments eventually had school programs association with them. This is an aerial view of the playing fields behind St. Anne's Catholic School, which serves River Oaks residents. (Courtesy of Micheal Flores Photography.)

DISCOVER THOUSANDS OF LOCAL HISTORY BOOKS
FEATURING MILLIONS OF VINTAGE IMAGES

Arcadia Publishing, the leading local history publisher in the United States, is committed to making history accessible and meaningful through publishing books that celebrate and preserve the heritage of America's people and places.

Find more books like this at
www.arcadiapublishing.com

Search for your hometown history, your old stomping grounds, and even your favorite sports team.

Consistent with our mission to preserve history on a local level, this book was printed in South Carolina on American-made paper and manufactured entirely in the United States. Products carrying the accredited Forest Stewardship Council (FSC) label are printed on 100 percent FSC-certified paper.

MADE IN THE USA